NEWHAM IN 50 BUILDINGS

MALCOLM BATTEN

AMBERLEY

First published 2023

Amberley Publishing, The Hill, Stroud
Gloucestershire GL5 4EP

www.amberley-books.com

British Library Cataloguing in Publication Data.
A catalogue record for this book is available from the British Library.

ISBN 978 1 3981 1323 7 (print)
ISBN 978 1 3981 1324 4 (ebook)

Typesetting by SJmagic DESIGN SERVICES, India.
Printed in Great Britain.

Contents

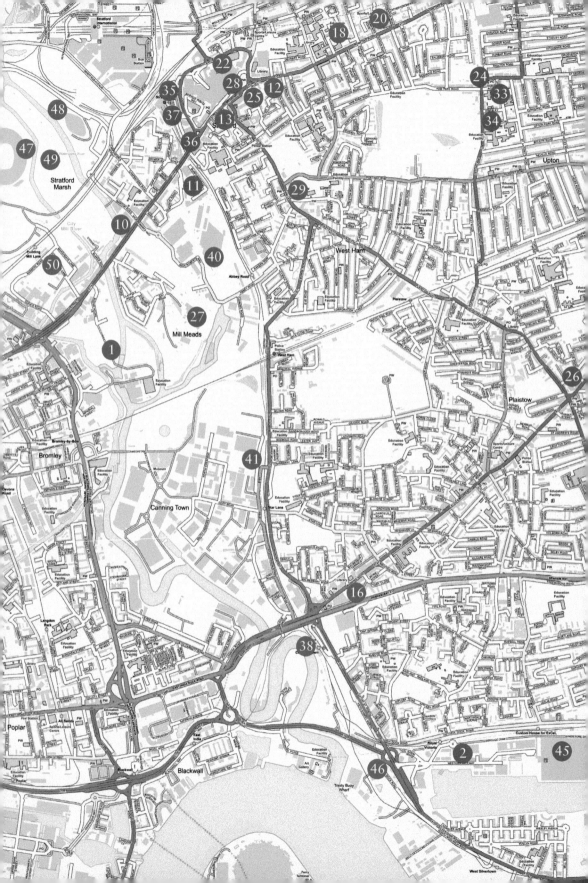

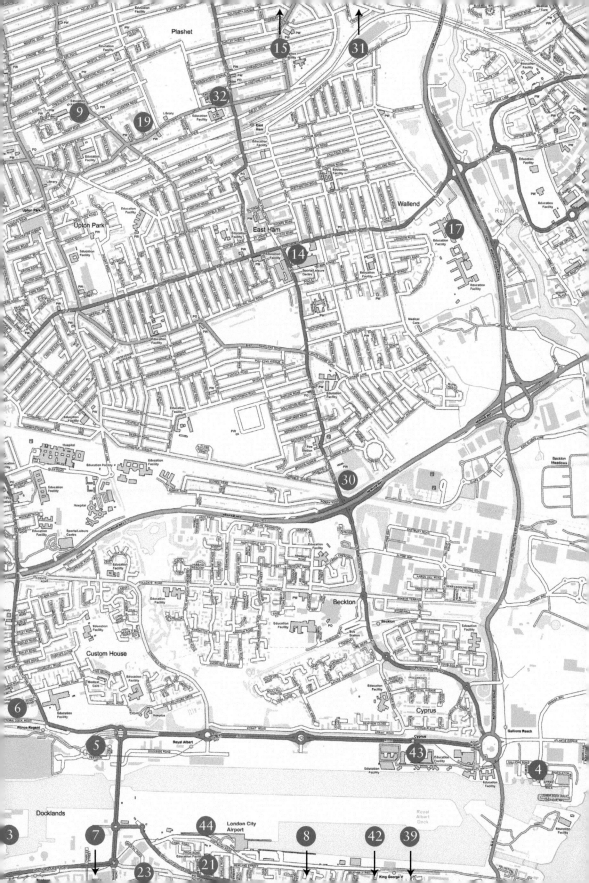

Key

Introduction

The London Borough of Newham was created in the 1965 reform of London local government by the merger of the County Borough Councils of East Ham and West Ham, which occupied the closest part of Essex to the City of London itself. Being County Borough Councils, two of only three such authorities in the Greater London area, meant that they had the same set of powers as a County Council including education, fire and ambulance services in their areas, unlike Borough Councils or Urban District Councils, which had lesser powers than the county they were in. When the former boroughs were merged, it was decided to call the new London borough Newham, probably so as not to be seen as giving preference to either.

'Ham' or 'hamme' is an Anglo-Saxon word meaning a village or dwelling place. Also 'hamm' in Old English meant a water meadow. First recorded in 958 as one place 'Hamme', by the end of the twelfth century separate east and west settlements were noted. A market charter for West Ham was procured in 1247 by Richard de Montfichet. His ancestor, William de Montfichet, had founded the Cistercian Abbey of Stratford Langthorne in 1135, which was dissolved in 1538.

Before the nineteenth century, most industry would have been concentrated on the banks of the River Lea (or Lee). From early times, as the River Lea neared the Thames it divided into several tidal channels which flowed through marshy areas. The Romans built a ford, Queen Maud built Bow Bridge and in the fourteenth century the Abbot of Stratford Langthorne Abbey tried unsuccessfully to divert the river to avoid flooding. In the 1770s various parts of the River Lea between Hertford and London were supplemented by stretches of canal to ease navigation. These included the River Lee Navigation and the Limehouse Cut. The River Lea (Flood Relief) Act 1930 led to extra channels and locks being created, the whole complex being known as the Bow Back Rivers.

It was the coming of the railways from 1839 coupled with the rise of new technologies in the Victorian era, and legislation prohibiting many of the smellier and noisier industries from operating within London that led to the rapid growth of industry and population within Newham from the 1840s onwards. The area grew rich in the nineteenth century from industry, railway engineering and the docks. The area south of Plaistow and East Ham was largely uninhabited marshland until this time when it was purchased and drained to create the docks and the industrial areas of Canning Town and Silvertown. The area that now comprises North Woolwich and Beckton was actually part of Kent until 1965.

North Woolwich was not administered by East Ham as might be expected but was part of the Borough of Woolwich on the south side of the River Thames.

The continued importance of the area to London's economy was realised by the Luftwaffe who subjected it to heavy bombing in the Second World War.

Much of this industry fell into decline from the late twentieth century and the population was also falling. When the docks were closed in 1981 and relocated to Tilbury, due to new technology like containerisation, the London Docklands Development Corporation was set up to regenerate the Docklands area with London City Airport and a new University of East London campus taking their place. But their remit did not cover the decline of the Stratford area as the railway yards and workshops closed.

However, the borough, once one of London's poorest and most ethnically diverse, has seen a major regeneration, especially since the award of the 2012 Olympic and Paralympic Games to London with the main stadium events held at Stratford. Westfield Shopping Centre was built to accompany this. Now the borough is booming with new housing and other developments, especially around the former Olympic site. The London Legacy Development Corporation was set up to oversee the longer-term regeneration of the Olympic Park area and ensure that the Olympics site would not become a 'white elephant'. Part of the site became the Queen Elizabeth Olympic Park, the biggest new park in London in over one hundred years. West Ham United FC have moved into the Olympic Stadium, now renamed the London Stadium. Development is ongoing – a new university campus, UCL East is being built, and a new creative centre will open at East Bank in 2022–3, a joint venture with University College London, London College of Fashion, the BBC, Sadlers Wells and the V&A. The area has even been given its own new postal district – E20. The Elizabeth Line, aka Crossrail, now finally opened in 2022 will further boost the area, which as the council strapline goes is a place where 'people choose to live, work and stay'.

Unlike some of the other London boroughs such as Greenwich or Richmond, Newham has few buildings other than churches dating back before the nineteenth century. This is because much of the area was not developed until then. Nevertheless, there are four buildings that have a Grade I listing. There were a number of more gentrified properties in the Plaistow and Upton areas from the previous century or earlier, built as the country retreats for City merchants and businessmen. However, most of these have not survived. For instance, Ham House originated in the sixteenth century as Grove House, later known as Rookes Hall and later still as Ham House. In the eighteenth century the eminent surgeon Dr John Fothergill turned the site into one of the finest botanical gardens in Europe. Ham House was demolished in 1872. At that time it was owned by the Gurney family who sold the land in 1874 for use as a park – now West Ham Park. Central Park, East Ham and Stratford Park are also on the grounds of former large estates. Upton House in Upton Lane was the birthplace of Lord Joseph Lister (1827–1912), the founder of antiseptic surgery. The house was demolished in

1968. Cumberland House stood in Elkington Road off New Barn Street. It took its name from the Duke of Cumberland, George III's younger brother, who owned the house between 1787 and 1790. This was demolished in 1935.

Several of the municipal buildings in Newham, and elsewhere in the East End, were the gift of the Cornish businessman and philanthropist John Passmore Edwards (1823–1911). A journalist, editor and later Member of Parliament, he gave money to build more than seventy schools, libraries, art galleries and hospitals.

A selection like this will be subjective, and readers may argue that there are other buildings that are more worthy of inclusion. I can only say that this is a personal choice and I have endeavoured to select buildings that reflect different aspects of the area's past, as well as the present regeneration.

Photos are by the author except where stated.

Early Industry

1. Three Mills, Three Mill Lane, E3

Three Mills is situated on the Three Mills Wall River, one of a number of channels that branch from the River Lea to the north of Stratford and rejoin it at Bow Creek just south of the mill site. Collectively they are known as the Bow Back Rivers. From the Lea there flows the Channelsea River furthest east, then the Waterworks River, City Mill River, and Pudding Mill River. The latter three of these merge into the Bow Back River which runs into the Lea, and from which two other channels, the Three Mills Wall River and Three Mills Back River, run to join with the Lea and Channelsea rivers at Bow Creek. All of these rivers are tidal. They were essential for flood drainage but by 1930 some had become derelict and choked with rubbish. The Lea Conservancy Board and West Ham Borough Council obtained an Act of Parliament to carry out a wide-scale improvement scheme between 1931 and 1935. This involved the widening, dredging and diversion of some of the rivers, the filling in of others and the construction of new locks and bridges.

The origin of this complex pattern of channels has been attributed to King Alfred the Great. In the year 895 the Danes crossed the Channel and sailed up the River Lea to Hertford where they encamped to plan their next conquest further inland. Alfred sized the initiative and drained the Lea into channels, which left the Danish fleet high and dry. He then marched his army to Hertford, set fire to their fleet and defeated the invaders. However, the evidence that all the channels date from this event is inconclusive. They were however in place by the eleventh century. As the names of some of the rivers imply, there were mills on most of them and some channels may have been cut as mill streams. The Domesday Book of 1086 lists eight mills in the Stratford area – the largest concentration in Essex – so the tradition of milling in the area goes back a long way. These would all have been tide mills, as windmills were not yet in use in England at that time

In the Middle Ages flour milling and baking was an important local industry, Stratford bakers supplying much of the bread sold in the City of London. A small dock was built in the later Middle Ages for unloading grain brought down the Lea for milling. Faggots from Epping Forest provided fuel for the bakers' ovens.

The abbey of Stratford Langthorne came to an end when Henry VIII dissolved the monasteries in 1538. Nothing now remains of the abbey, although the site

is remembered in local street names. The lands and mills passed to private landowners (who also had to take on upkeep of the bridges). The mills first passed to (Sir) Peter Meutis in 1539. There were two watermills at the time. In 1588 one of these was in use as a corn mill, the other for gunpowder. After a succession of owners, the mills were sold in 1727 to Peter Lefevre, a Huguenot, who in partnership with others built up a large distilling process there.

The 'Three Mills' are now the only survivors of all of these Stratford area mills. The present buildings consist of two tide mills, the House Mill of 1776 and its attached Miller's House, and the Clock Mill of 1817. There was also a windmill, south of these buildings, first mentioned in 1734, which lasted until around 1840. It was this, rather than any of the other mills, that probably gave rise to the location's name. The two remaining mills were bought by J & W Nicholson, gin distillers, in 1872. The mills operated in conjunction with a distillery on adjacent land. Milling continued at the House Mill until 1940 when the mill received war damage, and some ancillary buildings were destroyed. The Clock Mill was in use until 1952.

The mills were sold to the Greater London Council in 1966, which leased part of the premises to Three Mills Bonded Warehouses Ltd, a company partly owned by J & W Nicholson.

After years of disuse the remaining mills received listed status and have been restored progressively since the 1980s. First to be restored was the newer Clock Mill, which is now converted to offices. The Grade II listed building, built in 1817, is five storeys high with 18-inch-thick stone walls. Timber floors are supported on timber beams, which rest on circular cast-iron columns. There is a timber trussed roof with slate covering. On the south side, projecting over the river is a weatherboarded loading hoist or 'lucam'. At the west side are two brick kilns with circular slate-covered roofs added in the nineteenth century. The clock tower alongside, incorporated from an earlier mill on the site, has a timber-framed and clad turret. The clock dates from 1753 and a brass plate on the mechanism reads 'Charles Penton Moorfields MDCCCLIII repaired by Bruton 1813'. Although the mill machinery has gone, the wheels, all undershot, remain in situ. There are three wheels, two being of 20 feet in diameter; the other is 19 feet 6 inches. One wheel is marked 'Fawcett & Co. Phoenix Foundry Liverpool'. They powered fourteen pairs of millstones.

The House Mill is the world's largest surviving tide mill. This dates from 1776 and has a Grade I listing. It carries a plaque with the monogram 'DSB 1776' after the builder Daniel Bisson, a partner of Peter Lefevre. The five-storey building straddles the Three Mills Wall River. The sides and south facade facing the road are in brick, while the north facade is timber framed and clad. The roof had been of slate, but evidence found during restoration confirmed that originally clay tiles were used, so these were used in the restoration. Some of the original equipment has survived including some millstones and grain chutes. This mill has four undershot wheels, three of which are 20 feet in diameter, the other 19 feet. Two of

the wheels are of the Poncelot type with curved blades. This design was introduced by J. V. Poncelot in the early nineteenth century and increases the efficiency of an undershot wheel from around 22 per cent to around 65 per cent. Twelve pairs of stones were driven by these wheels.

The former Customs House alongside the Miller's House, and the cobbled roadway have both been given a Grade II listing.

In the multi-million-pound restoration of the area, both mills are now fully restored externally, and the House Mill is restored internally. The Miller's House is a new building behind the reconstructed facade of the original house. Now owned by the House Mill Trust (formerly the River Lea Tidal Mill Trust), the House Mill and Miller's House are open to visitors for tours on most Sundays. A visitor centre with educational facilities has been installed in the Miller's House so that school classes can study the working environment of past times.

Significant improvements have also been made to the area surrounding the mills. A new access road has diverted traffic from Three Mills Lane in front of the buildings. Footpaths have been improved, landscaping has taken place, new railings installed, trees planted, etc., to improve access and make the area more attractive to visitors. The area forms part of the Lea Valley walkway.

All this has not come cheap. Much of the cash came from the European Regional Development Fund. Other money came from English Heritage, the Lea Valley Regional Park Authority, Newham Council's Stratford City Challenge project, and other sources. However, a lottery money application to get the wheels restored to working order has been unsuccessful.

Another part of the former distillery site is still in commercial use – but for a use far removed from any of its former roles. The Workspace Group, founded in 1987, acquired a 20-acre site, and spent £8 million developing it as studios. There are now eleven filming stages and nine rehearsal rooms. The site has been used for TV programmes including *Bad Girls*, *London's Burning* and *Big Brother*, and for films including *Lock, Stock and Two Smoking Barrels*. The old bottling plant, behind the Clock Mill, is now the main administration block and sports a new curved roof.

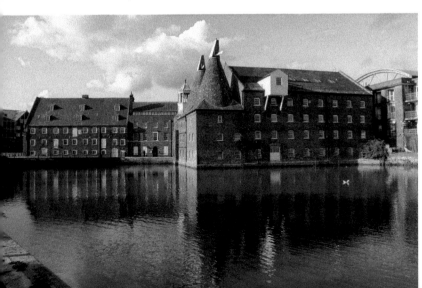

The two surviving mills with the House Mill and Miller's House on the left and Clock Mill on the right, as seen in 2018.

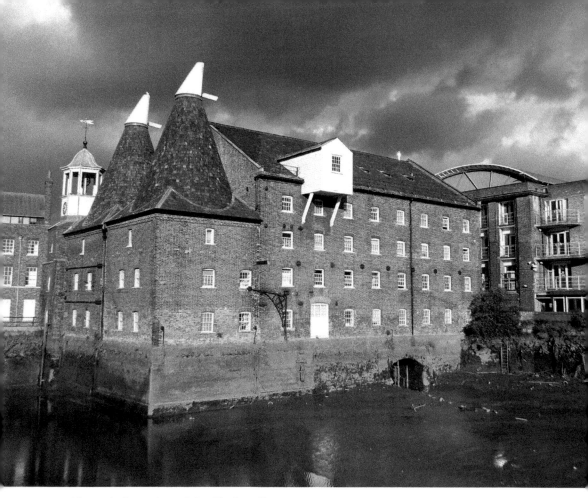

Above: A closer view of the Clock Mill in 2018.

Below left: The restored House Mill with the Miller's House beyond it.

Below right: The wall plaque mounted on the House Mill.

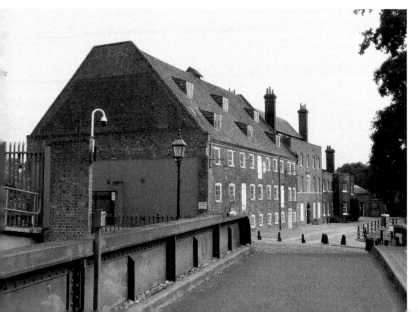

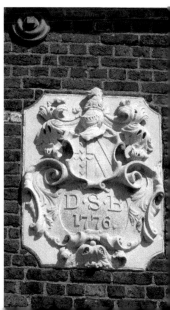

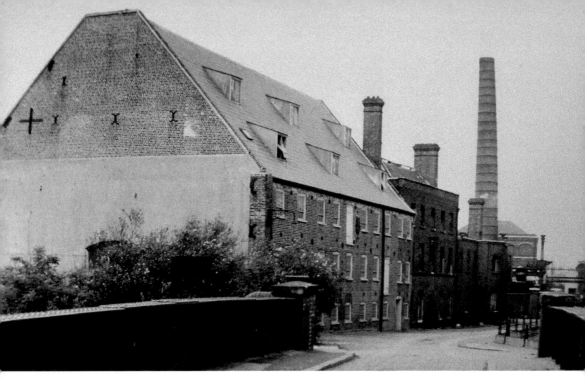

Above: The House Mill and Miller's House in the late 1940s. The tall chimney beyond has since been removed. (Reg Batten)

Below: The rear view of the House Mill in the late 1940s. Wartime damage to the Miller's House is evident. (Reg Batten)

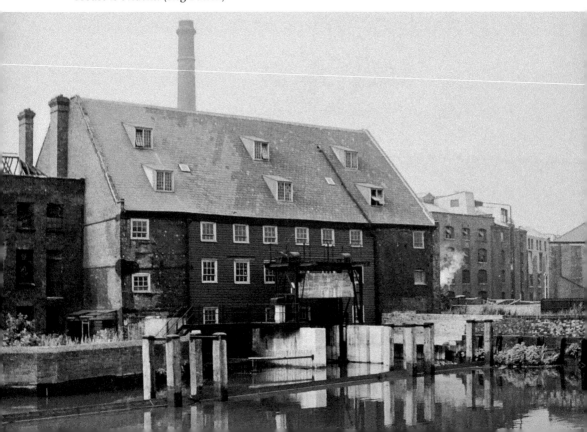

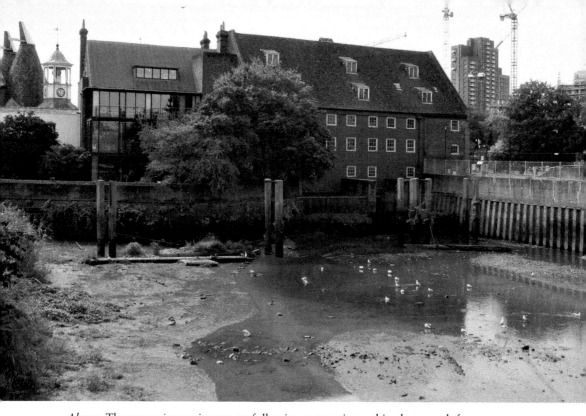

Above: The same view as it appears following restoration – this photograph from 2020.

Below: An interior view of the House Mill as it was in the 1990s. (Reg Batten)

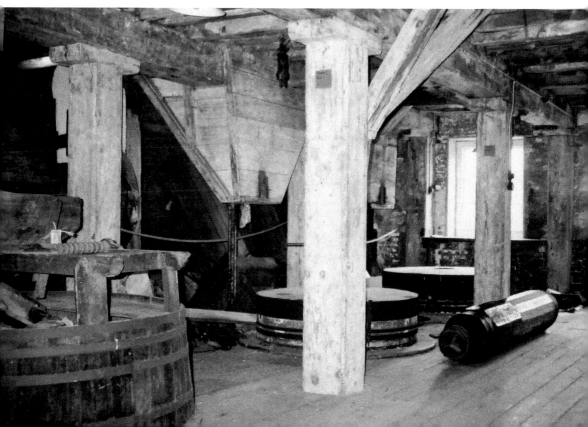

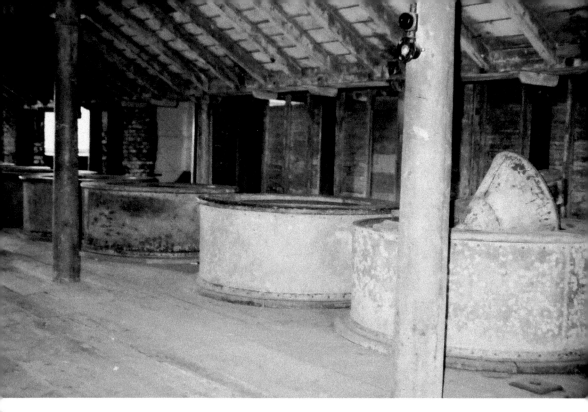

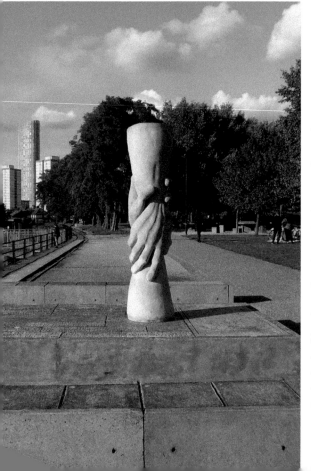

Above: Another view of the interior.
(Reg Batten)

Left: The Helping Hands memorial
by artist Alec Peevor, erected in 2001,
commemorates a tragic incident on
12 July 1901. Godfrey Nicholson,
Managing Director of mill owners
J & W Nicholson, and three co-workers
went to check on the water level of
a nearby sealed well. One of these,
Thomas Pickett, descended into the well
but as he climbed back up the ladder he
fell into the water. Godfrey Nicholson
went to help him, but he too fell into the
water. The other two workers also went
down to help but they also fell in. A
fifth worker, Job Vanning, then climbed
down, but with a rope tied about his
waist. He went limp but was pulled to
safety. It was later found that when the
well had been sealed, rotten plants had
released carbon dioxide into the water.
Toxic fumes were released when the
water was disturbed by Thomas Pickett,
which overcame each man in turn. After
the bodies were recovered, the well was
sealed permanently.

The Royal Docks and Ancillary Services

The 'Royal Docks' – Royal Victoria Dock (1855), Royal Albert Dock (1880) and King George V Dock (1921) – comprised between them the largest area of impounded dock water in the world with over 11 miles of quays. However, with the advent of containerisation and the decision to concentrate all new development at Tilbury they closed to commercial shipping in 1981 and after a period when they were used for laid-up shipping they closed finally in 1985. The London Docklands Development Corporation was set up to fast-track the redevelopment of London's docklands. Consequently, most of the former dock premises have been swept away. Some of the original warehouses, now listed buildings, remain at Royal Victoria Dock and there are a couple of former Port of London Authority buildings that housed equipment to control the level of water within the docks.

2. Royal Victoria Dock Warehouses, Western Gateway, Royal Docks, E16

The Victoria (later Royal Victoria) Dock opened in 1855 and was the first of the London docks designed for steamships and to be rail connected. It was also the first to make use of hydraulic power. The main proposer and chief architect was George Parker Bidder. Bidder and his associates had formed the North Woolwich Land

Warehouse blocks O and N as seen in 2019. Of Bidder's original three-storey bonded tobacco warehouse of 1859 (block K), only part now remains. Reconstruction in 1925 following a fire led to the original party wall being taken down and new roofs and party walls constructed to create blocks N–R. These were restored for the LDDC by Rees Johns Bolver architects in 1994–95.

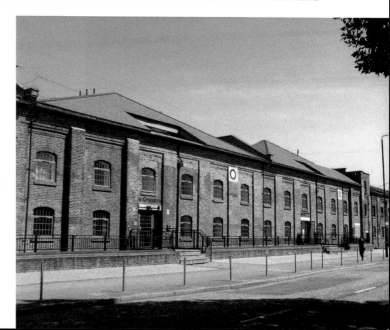

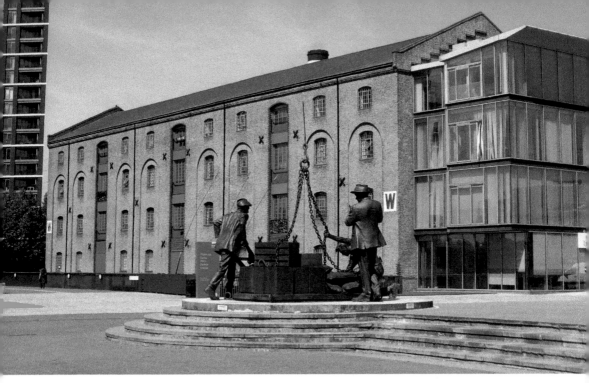

Warehouse W dates from 1883 and was designed by company engineer Robert Carr. This has four storeys and before the dock was remodelled would have been at the dock edge. The statue outside, entitled *Landed*, by Australian sculptor Les Johnson, was unveiled in Royal Victoria Square on 24 August 2009. The statue features three actual dockworkers – Johnny Ringwood, Mark Tibbs and Patrick Holland – and is dedicated to all the dock workers and their families. Johnny Ringwood and Patricia Holland, whose father and husband both worked on the docks, campaigned to raise the funds to create this statue.

Company and bought up most of the riverside marsh at a few pounds per acre from Bow Creek to Gallions Reach and from the Barking Road to the River Thames. Originally the dock had 'finger jetties' that projected at right angles from the north side but these were demolished in 1935–39 when the north side of the dock was remodelled and five reinforced-concrete warehouses were built. The dock handled frozen meats, fruit, butter and tobacco as well as general goods. Since closure, while most of the buildings have gone, some of the original warehouses, now Grade II listed, have been retained and are either converted into offices or flats.

3. Spillers Millennium Mill, Rayleigh Road, Royal Docks, E16

This was built in 1905 for William Vernon & Sons of Birkenhead. Construction was overseen by W. A. Vernon. It was one of three large flour mills built for different companies on the south side of Royal Victoria Dock in the early twentieth century but is the only survivor. The name derived from the company's most successful product, the prize-winning 'Millennium Flour'. The company was taken over by Spillers in 1920, an established flour-milling company who also

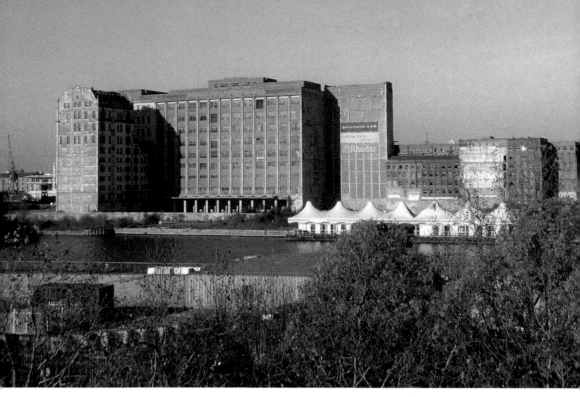

Above: The view seen from the Docklands Light Railway in 2018.

Below left: The front view of the Millennium Mills in 2020.

Below right: The listed D silo in October 2022 with some redevelopment work being undertaken in the foreground.

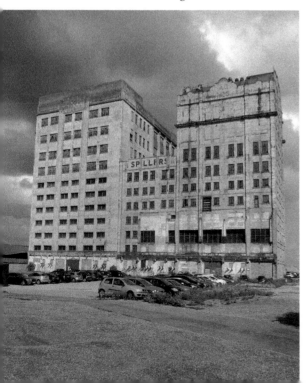

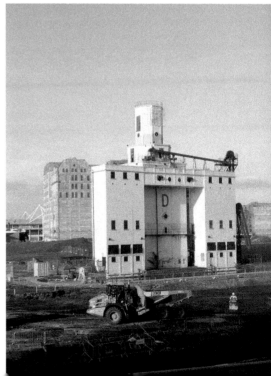

diversified into animal feeds by 1927. The mill was rebuilt as a ten-storey concrete building in art deco style in 1933. The mill received substantial damage during the Second World War and was rebuilt by 1953 with a windowless steel-framed infill on the west side. It closed down when grain-handling facilities were transferred to the new Tilbury Grain Terminal in 1969. Various development plans since then have come to nought, although the building has been stripped of internal machinery and asbestos. It has however featured in a number of TV series and films including Derek Jarman's *The Last of England* (1987). In 1988 Jean-Michel Jarre had the Millennium Mills painted white as a surface for projecting lighting effects for his show *Destination Docklands*, held in the docks. The D silo nearby is Grade II listed. New plans for the multi-million-pound redevelopment of the mill and surrounding area were announced on the BBC London News on 5 July 2022.

4. Gallions Hotel, Albert Basin Way, Royal Docks, E16

The Gallions Hotel was built *c.* 1881–3 by the London & St Katharine Dock Company as the New Hotel to serve passengers boarding liners from the Royal Albert Dock. It was designed by George Vigers and T. R. Wagstaffe. There was a Gallions station on a branch off the line to North Woolwich, but this closed in 1940 following bomb damage. The hotel was built with four storeys, providing kitchens and cellars at ground level, public rooms at first floor, and bedrooms on the upper floors. The main entrance is at first-floor level from a tiled podium built over the wine and beer cellars. The second floor has a plaster frieze by Edwin Roscoe Mullins decorated in blue and white. There is a small domed turret with a weathervane on the south side. The hotel closed in 1972 and was then left

The Gallions Hotel as it has now been renovated.

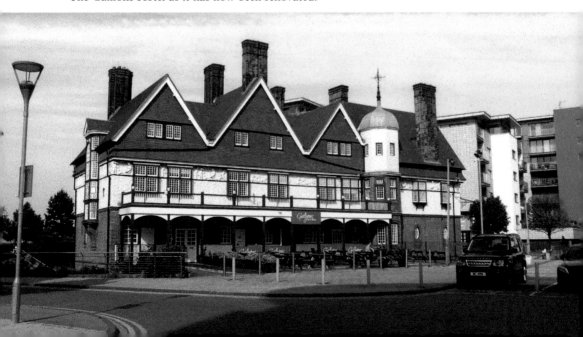

derelict for many years, suffering from vandalism. Planning permission to move it to another site was sought in 1989 but this did not happen, and the hotel has since been renovated and renamed 'Galyons'. After the station closed part of the platform remained as an open raised area in front of the hotel but this has now been landscaped into the seating area seen here. The hotel has a Grade II listing.

5. Connaught Tavern/Fox Connaught, Lynx Way, E16

This building, dating back to 1881, was originally the Connaught Tavern. A design was drawn up by architects George Vigers and T. R. Wagstaffe, although the building varies from the original plan in that a fourth storey was added. It was originally built to cater for passengers disembarking from ships in Victoria Dock. After passenger numbers declined as passenger traffic transferred to Tilbury, the tavern was used more by dock labourers waiting to see if they would be offered a day's work. After seventeen years of closure it was reopened in 2003 by the small Fox pub chain as the Fox Connaught. The building has been given a Grade II listing since August 1998.

Right: A general view of the building as it is now. The tall chimney stacks add to the sense of height.

Below: This tile plaque can be seen mounted on the south side above the first-floor terrace with its timber balustrade.

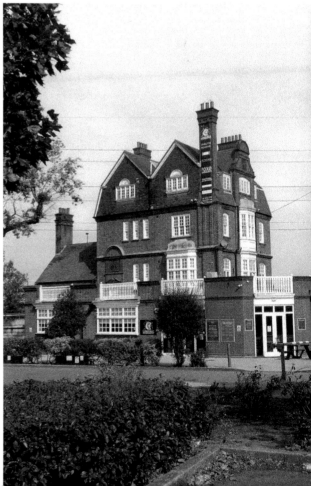

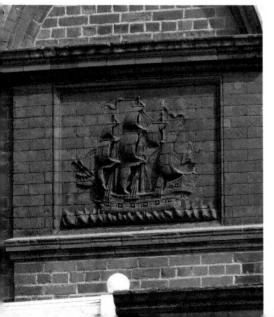

6. Flying Angel Hostel, 287 Victoria Dock Road, Custom House, E16

The imposing 'Flying Angel' hostel was opened by the Missions to Seamen in 1936. It replaced an earlier establishment, the Louisa Ashburton House, erected by the British & Foreign Sailors Society. This had been demolished in 1930. The eight-storey 'Flying Angel' brick building by Petch and Fermaud contained hostel accommodation, public rooms and a chapel. The Asiatic Hostel opened in the adjacent Ashburton Hall in 1937 to provide facilities for Indian seamen. Both buildings received war damage during the Blitz, and the Asiatic Hostel was later demolished. The Flying Angel however remains and still dominates the skyline at its location opposite Custom House station. It closed as a seamen's hostel in 1973. It was later owned by Beacon hostels but is now converted to flats. The roof has an open turret which contained a flashing light, and this is surmounted by a weathervane in the form of a four-masted sailing ship.

Left: The Flying Angel hostel. Note the weathervane just visible on the roof.

Below: The motif over the entrance that gives the hostel its name.

7. Thames Flood Barrier, Silvertown to New Charlton

The origins of the Thames Flood Barrier date back to the disastrous floods of 1953 which caused considerable damage to the east coast of England and devastated parts of the Thames Estuary and East London. The Waverley Report into this predicted that strong surge tides could submerge large sections of the capital. There was also significant flooding around Silvertown in 1957. The Thames Barrier and Flood Prevention Act 1972 authorised the construction of a barrier. The rotating gate design was devised by Charles Driver in 1969. Designed by architects Rendel, Palmer and Tritton, construction took place from 1974 until completion in 1982. Ten steel gates span a distance of 520 metres. They normally lie flat on the riverbed to allow shipping to pass but can be raised to a vertical position when surge tides are forecast. The 61-metre-long main gates weigh 3,300 tonnes each. Two giant floating cranes were hired from the German company Neptun of Hamburg and worked in tandem on the precision lifts. The gate sections were transported to the site on 6,000-ton capacity barges. The barrier was officially opened by HM the Queen on 8 May 1984, although the gates were first used operationally in February 1983. Full closure takes thirty minutes, and the barrier has been closed just over 200 times since it was completed in 1982. The control centre and visitor centre are on the south side of the river. The barrier was constructed at a cost of £534 million. Another £100 million was spent on raising and strengthening other river defences. The Thames Barrier is operated by the Environment Agency.

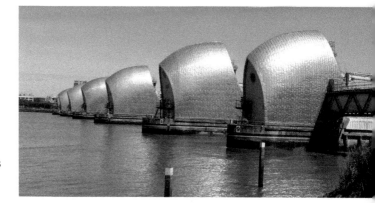

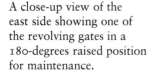
The west side of the Thames flood barrier seen from the south bank.

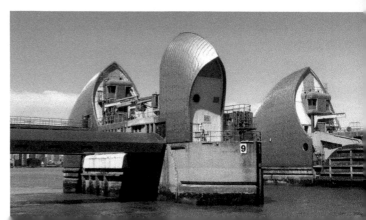
A close-up view of the east side showing one of the revolving gates in a 180-degrees raised position for maintenance.

Industry & Commerce

8. Tate & Lyles Thames Refinery, Factory Road, Royal Docks, E16/Plaistow Wharf Refinery, Knights Road, Silvertown, E16

Henry Tate opened the Thames Refinery at Tay Wharf, Silvertown, in 1878. Four years later Abram Lyle opened the Plaistow Wharf Refinery less than a mile away. The two companies merged in 1921 after the death of both founders, who apparently never met. Both refineries remain in use. Thames Refinery is the largest in the EU and one of the largest in the world with a capacity of 1.2 million tonnes per annum. Tate & Lyles has been owned by ASR Sugars of America since 2010.

Tate & Lyle's Thames Refinery seen from the south bank. Henry Tate opened the Thames Refinery at Silvertown in 1878 to refine cane sugar and make sugar cubes. On 13 March 2008, Her Majesty the Queen and the Duke of Edinburgh visited the refinery to celebrate 130 years of production, and where she unveiled a plaque in the main yard.

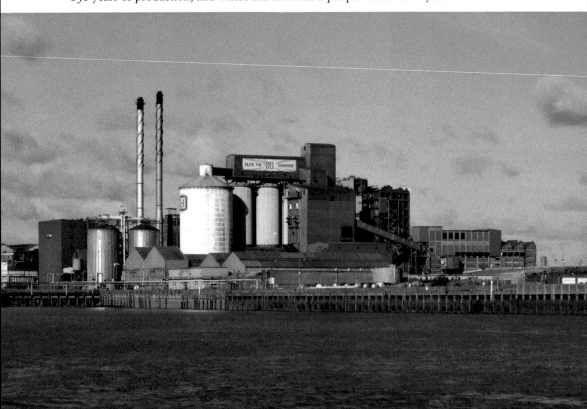

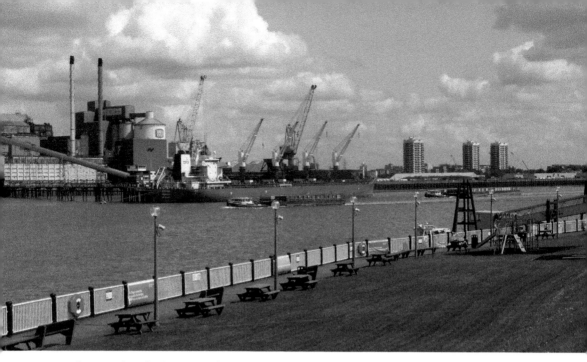

Above: A ship discharges at the refinery in 2019, as seen from the Thames Barrier visitor centre park. The refinery receives some thirty to thirty-five ships a year. Bulk carriers are unloaded by grab cranes discharging into hoppers, replacing the former carriage in sacks.

Below: The Plaistow Wharf Refinery at West Silvertown was opened by Abram Lyle in 1882. This was four years after Henry Tate had opened the Thames Refinery less than a mile away. This is the home of Lyle's Golden Syrup, a by-product of the cane sugar refining process. The iconic tin design was first introduced in 1883 and is recognised by Guinness World Records as the world's oldest unchanged brand packaging. More than one million tins are produced every month.

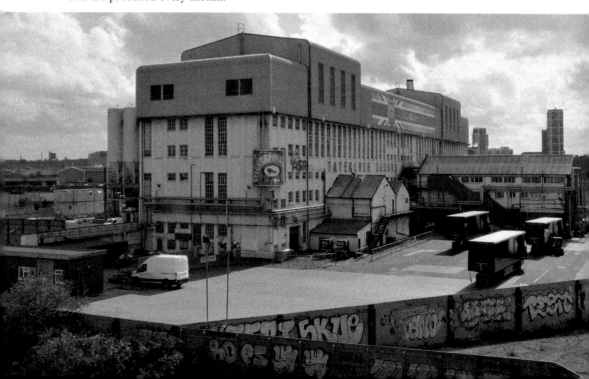

9. Trebor Sweets Factory, Katherine Road, Forest Gate, E7

In 1907 Messrs Woodcock, King, Robertson and Marks opened a sweets factory in Forest Gate. It was built around a row of pre-existing houses called Trebor Terrace, off Katherine Road and hence the name was adopted in 1918. A new factory, in contemporary modernist style, was built on the site in 1935. The Forest Gate factory suffered bomb damage during the war. On repair it was painted white and the 'Trebor Quality Sweets' lettering applied. Later expansion saw them open another factory at Chesterfield in the 1930s, and in the 1950s take over an old coach factory in Woodford Road, Ilford. By the 1960s Trebor claimed to be the UK's largest confectionary maker and exported to over fifty countries. However, in 1989 they were taken over by Cadburys and the factory closed down. The 1935 factory survives, little altered externally but now converted to apartments in 2003.

The former Trebor Factory in Katherine Road.

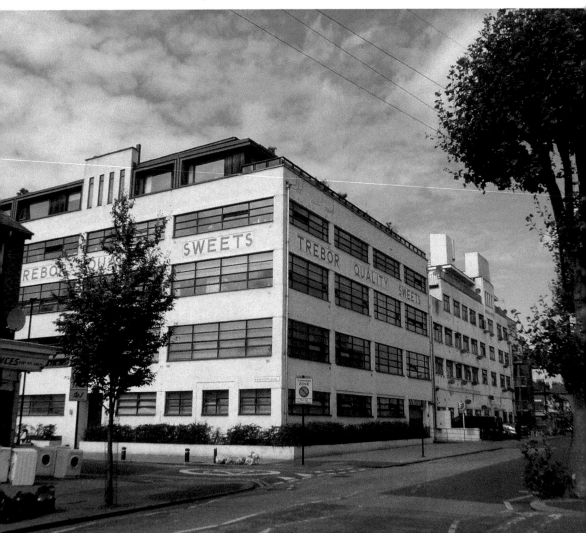

10. Yardley Building, 150 Stratford High Street, E15

Described by Pevsner as 'Quite good, straightforward Modern', this was built in 1937 by Higgins and Thomerson. It comprises a four-storey office block linked by a staircase tower to a semi-circular west-facing bay. This building is the only surviving part of the former Yardley soap and perfumes business. The company was originally founded by the Cleaver family in 1770. They built a factory in Carpenters Road, Stratford, in 1904 (now demolished). Additional land in Stratford High Street was acquired in 1918 for storage, distribution and box making. In 1913 Yardley had purchased an engraving of Francis Wheatley's *The Flower Sellers* which became their trademark, and it is this tiled image that is the distinguishing feature of the building. In 1963 Yardley were refused permission to expand the site at Stratford and instead took out a lease on a site at Basildon, Essex, to which they moved in 1966. The building has been redeveloped by Genesis Housing Group as a mixed development of residential apartments and commercial use named Warton House.

Right: The former Yardley building as it is now.

Below: A close-up of the tiled image.

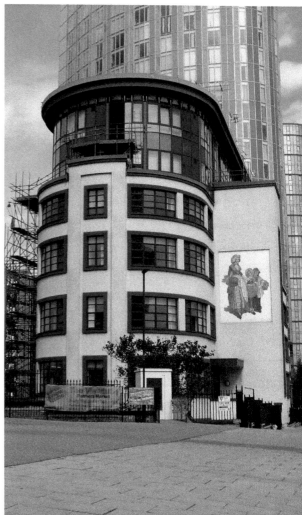

11. Stratford Workshops, Burford Road, Stratford, E15

The Eastern Counties Railway, who first established a railway to Stratford in 1839, set up its own printing department in 1844, which passed to the Great Eastern Railway on takeover in 1862. In 1893 a new four-storey building was constructed in Burford Road with a working area of 46,720 sq. feet. This was responsible for all the company's printing requirements. It was separated from the adjacent Stratford Market station by a pair of freight tracks but a tower and elevated footways (since demolished) gave access from the platforms. The printing

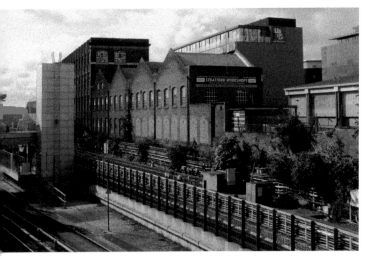

Left: Stratford Workshops with the Jubilee line and Docklands Light Railway's Stratford High Street station to the left.

Below: A view of the main workshop building taken from the DLR station. The bricked-in areas on the first and second floors show where the elevated footways to the station once projected.

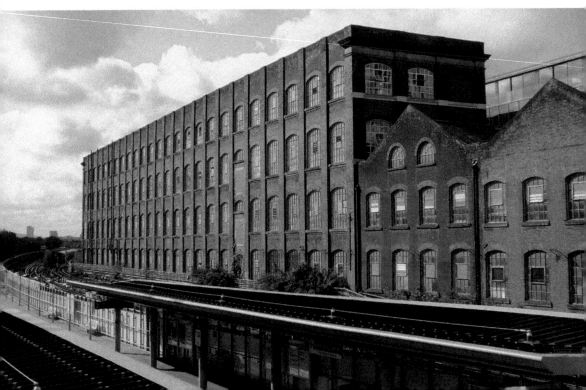

works passed in succession to the LNER and British Railways before eventual closure. The former buildings survive and are now owned by Newham Council. Known as Stratford Workshops, they provide space for small businesses.

12. The Old Dispensary, 30 Romford Road, Stratford, E15

Built between 1690 and 1720, this weatherboarded house is one of the oldest secular buildings in Newham. From 1861–1879 it housed a dispensary on the initiative of Dr William Elliott, the Medical Superintendent of the West Ham Union. This was later replaced by a new dispensary which in the 1870s became Queen Mary's Hospital for the East End in West Ham Lane. Then after 1885 the building became the headquarters for Arthur Webb's builders and shopfitters and was known as Langthorne Works. The building was granted Grade II listing in 1950. In 1973 the building was leased by Newham Council as offices of the Newham Museum Service and Stratford City Challenge Team.

By 2020 the Old Dispensary was out of use, but in late October one side had been leased out and was in use as a Romanian/Spanish shop. This use had ceased by December and in 2022 the building was once again for let as offices.

The Old Dispensary as seen in mid-2020.

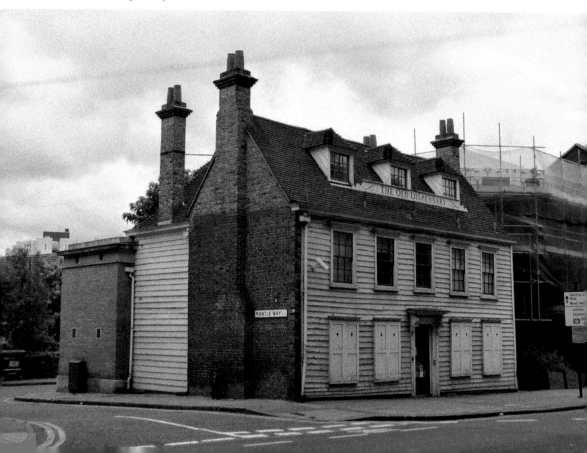

Municipal Pride

13. West Ham Town Hall, Stratford Broadway, E15

The Town Hall was built in 1867–68 for the West Ham Local Board of Health before being created a borough. The architect was Giles Angell. Pevsner describes the style as 'debased arched Cinquecento'. It was surmounted by statues representing Justice, Liberty, Fortitude, and other virtues, now removed. The Town Hall was extended in 1885, the architect being Lewis Angell F.R.I.B.A., and the builders M. A. Palmer & Co. Originally a fire station for two horse-drawn engines was provided in a court to the west side of the Town Hall. This was replaced in 1877 by a narrow building between the Town Hall and Bonallack & Son's Carriage Works next door. A plaque over the entrance to this can still be seen. In 1906 the fire station was enlarged

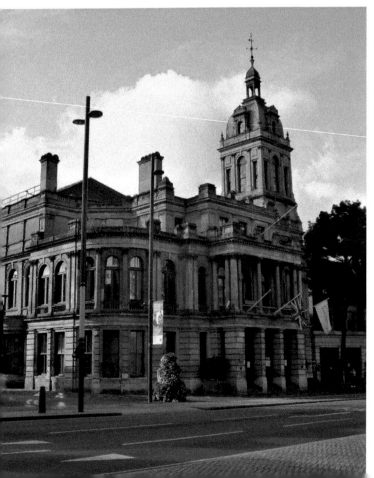

The Town Hall viewed in 2020.

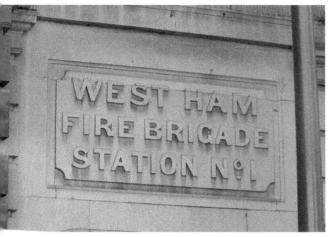
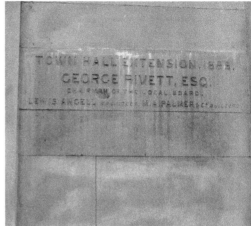

Above left: The Fire Station plaque dating from 1877.

Above right: The plaque commemorating the 1885 extension.

by taking over Bonallack's carriage shop which provided four bays for motorised fire engines. Bonallack's workshops were replaced by accommodation blocks for firemen. These later became council offices named Alice Billings House. The Stratford fire station was replaced by new premises in 1964 as it had become too cramped and increasingly blocked by growing traffic, the old site being adapted as offices. The Town Hall remains largely unchanged externally, having been restored in the 1980s following a fire and for the borough's centenary in 1986.

14. East Ham Town Hall, 328 Barking Road, E6

The Town Hall was built between 1901 and 1903, being opened in 1903 by John Passmore Edwards. The design was the result of public competition with the winning design coming from architects Henry A. Cheers of Twickenham and Mr Jos Smith of Blackburn. The main buildings form an L-shaped block with an assembly room, 100 feet by 50 feet seating 1,200 people plus various civic offices. A separate Technical College in a similar style was built to the east, and a public library, also in similar style, was added in 1908. The whole area complex also included a fire station and tram depot. The main building materials were red Accrington bricks and Doulton's biscuit-colour terracotta dressings, along with a slate roof. An elaborate banded clock tower stands at the north-west corner. The style can be described as a mixture of Tudor and Edwardian Baroque. Interior features to the halls and offices included mosaics, glazed tiling, Devonshire marble and fibrous plaster. The whole edifice was a statement piece, showing off the wealth and pride of this County Borough. Some of the buildings have since been replaced by more modern constructions, including the fire station and library, but remain in alternative use.

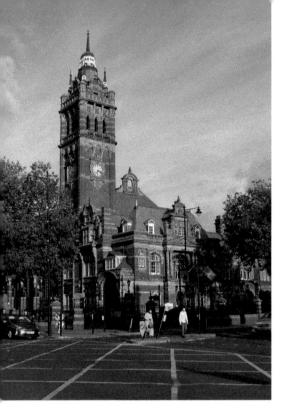

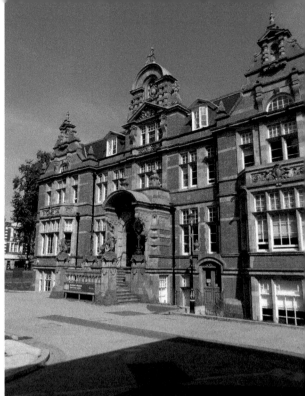

Above left: East Ham Town Hall, on the corner of Barking Road and High Street South.

Above right: The Technical College building, now a sixth-form centre. This originally offered trade and scientific courses and was opened by the Prince and Princess of Wales in 1905.

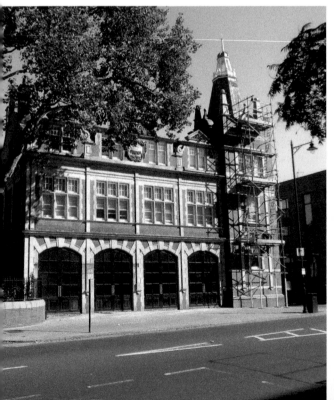

Left: The former Fire Station alongside the Town Hall.

Below: The plaque mounted at the top of the now disused but recently restored Fire Station.

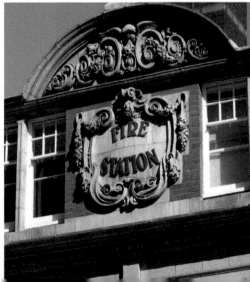

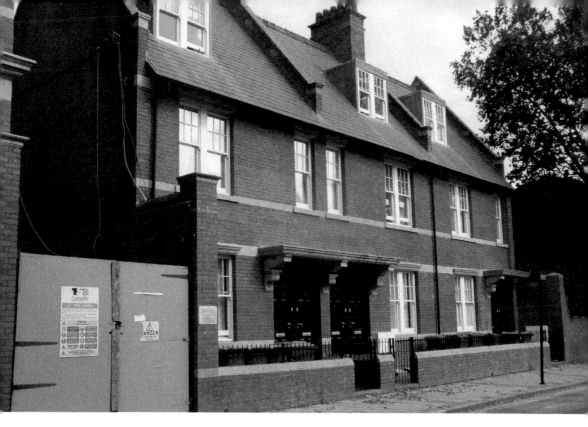

Above: Houses in Nelson Street, built as part of the Town Hall complex.

Right: East Ham (and West Ham) ran trams and the East Ham tram depot was built as part of the Town Hall complex. After its demise as a tram depot it was used to house council vehicles. Part of the building in Nelson Street, East Ham, is seen here.

Below: This wall plaque is mounted on the building to mark the location of the former East Ham Council tramways depot.

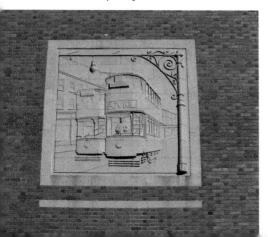

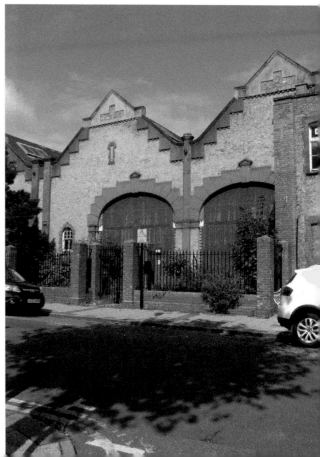

15. Manor Park Library, Romford Road, E12

This library was opened for the County Borough of East Ham in 1904, funded by the philanthropist Andrew Carnegie. The highly ornamented red-brick and terracotta building designed by the Borough Engineer Mr Campbell has a lecture hall on the first floor which was also used inter alia for wedding receptions and a separate newspaper reading room adjacent in Rabbits Road. The names of worthy literary writers – Milton, Shakespeare, Tennyson, Carlyle and Dickens – are set above the windows, while over the front door is inscribed 'Let there be light'. The words 'Carnegie Library' are also inscribed while there is a bust of the benefactor mounted high on the west wall. The library was replaced by a new, fully accessible library (or Neighbourhood Community Centre as it is named) at Manor Park Broadway and is now home to Rabbits Road Press, a community Risograph print studio and publishing press managed by Bow Arts. The interior was repaired and restructured in 2015 for its new purpose.

The former library building on the corner of Romford Road and Rabbits Road.

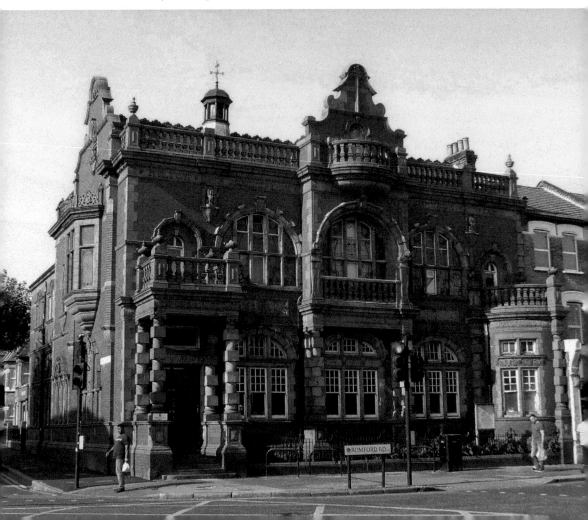

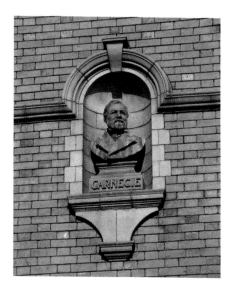

The bust of Andrew Carnegie mounted high on the west wall.

16. Canning Town Library and Public Hall, 105 Barking Road, E16

Construction of Canning Town library began in 1892 and it was opened in 1893 by the philanthropist John Passmore Edwards who donated the first 1,000 books, and this was West Ham's first permanent public library. The architect was Lewis Angell who was also responsible for the West Ham Town Hall extension. It was cited in Pevsner's guide as 'red brick, retrograde Italianate'. It was originally provided with electric lighting generated by on-site gas engines, and featured tables with integral umbrella stands. There were two main rooms, one 65 feet × 30 feet, the other slightly smaller. The library has now been replaced by new premises on the opposite side of Barking Road but a new chapter in its history is about to begin.

'In 2022 Newham Council was waiting to hear back about whether it had been successful in its bid to the UK government's Levelling Up Fund. We found out in late October that this had been successful, to the tune of £40 million worth of capital funding, £6 million of which is to be spent on turning the old Canning Town Library building on Barking Road into a modern and exciting heritage and culture centre for Newham. This is obviously extremely exciting, but the work we've needed to do in getting the project ready to begin spending money in March 2022 has occupied all of my time these past few months!' (Jess Conway – Archivist, London Borough of Newham). At the end of 2022 the council agreed to apply for £5 million from the National Heritage Lottery Fund for an archive and museum objects research room, more exhibition spaces, and a computer suite.

The building to the right of the library is the Canning Town Public Hall. This was built in 1894 to serve as the administrative centre for Canning Town and the surrounding area. This has a mosaic terrazzo floor to the entrance lobby and a large hall with stage at first-floor level. The hall had a long association with the Women's Suffrage movement. Sylvia Pankhurst and Daisy Parsons (who later

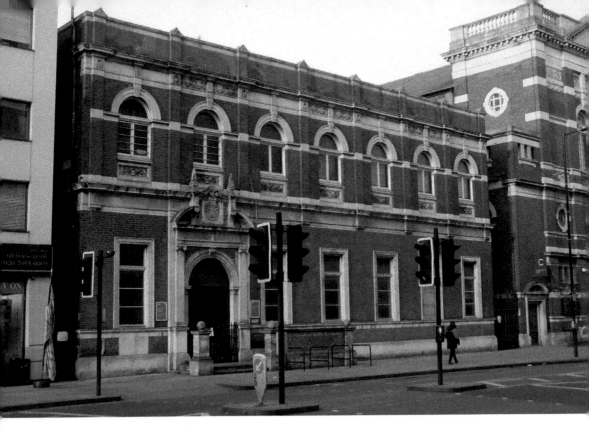

Above: The former Canning Town library and Public Hall to the right of it.

Left: The commemorative stone placed when the library was built.

became West Ham's first female mayor) both held meetings here. Will Thorne spoke at the site of the future hall in 1889 and went on to form the National Union of Gasworkers and General Labourers. He would later serve as Mayor of West Ham and MP for West Ham South.

From 1965 the hall served as an Adult Education Institute until 1989 when it was declared unsafe. It was then leased to local charity Community Links. The building was then restored under the direction of architect Richard Ellis, the work being completed in October 1993. The work cost £1.5 million but £1 million of this was raised by donations or through gifts of discounted materials. The buildings have a Grade II listing.

17. Langdon Academy, 96 Sussex Road, E6

In the years immediately after the Second World War, the Education Committee of East Ham Council decided to build brand-new schools for young people who would become 'a credit to themselves, their parents ... and their town'.

Langdon was the product of this vision. Building the schools was 'the costliest and most ambitious project ever undertaken in East Ham'. The final bill was over £1 million. The marshland (covered in watercress beds) and the Back River, running through the site, provided a considerable engineering challenge. Eventually the stream was culverted and the land was drained and filled in.

The Langdon Schools, as they were known at the time, were completed in 1953 and were acclaimed as one of the finest sets of school buildings in the country. Originally, three separate schools occupied the site – Burges Manor (girls secondary), Thomas Lethaby (boys secondary) and East Ham Grammar School for boys, which moved from its previous site at part of the Town Hall complex in Barking Road. In 1972 they were combined to form Langdon School, a mixed

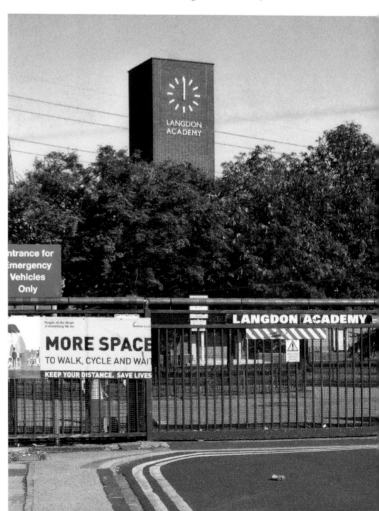

The Clock Tower still dominates the scene, although trees have grown up to obscure the surrounding buildings.

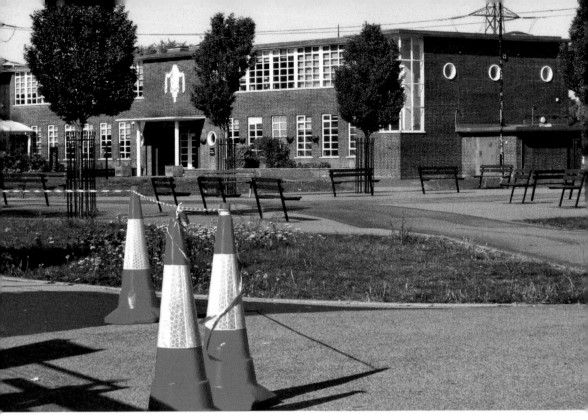

Part of the former buildings from the East Ham Grammar School for Boys.

comprehensive. In 2014 the school converted to become Langdon Academy as part of Brampton Manor Trust.

The architecture was typical for the period with two-storey long brick buildings that have large metal-framed windows. Each school had an assembly hall and gymnasium. The Grammar School had the East Ham coat of arms above the main entrance doors. A notable feature of the Langdon Schools was the central block surmounted by a clock tower. This housed the kitchens and dining rooms for each of the schools as well as some classrooms for the Grammar School. The site was surrounded by playing fields for each of the schools.

18. West Ham Technical Institute/University of East London, Water Lane, E15

The building was opened in 1898 as the West Ham Technical Institute and was the gift of the philanthropist John Passmore Edwards who described it as a people's university. At first there were courses in science, engineering and art. There was also a separate women's department. In 1921 it was renamed the West Ham Municipal College. After the Second World War it was expanded and became the West Ham College of Technology. It later became part of the North East London Polytechnic which has become, in turn in 1992, the University of East London. This now forms the Stratford Campus of the university, thus fulfilling the donor's description.

Construction was from 1895 to 1898. The architects were J. G. S. Gibson and S. B. Russell. It was built of red-brick and Portland stone with a steep slate roof. There is a carved frieze and much sculpture by W. Binnie Rhind. The style can perhaps be described as 'free classical'. Pevsner described it thus: 'Every conceivable motif is used which was available at that peculiar moment in the history of English architecture, when the allegiance to forms of the past were at last thrown to the winds … Altogether the architects have enjoyed being fanciful and have not minded being a little vulgar. But the whole is of a robust vitality which seems enviable today.' Inside, the Great Hall is 80 feet by 40 feet with a fibrous plaster ceiling.

A new Central Library opened alongside in October 1898, replacing West Ham's first temporary library in Rokeby House, Stratford Broadway. West Ham had been the second borough in Essex to adopt the Public Libraries Act of 1870. The new Central Library was paid for by 'Whisky Money' – a portion of the Port of London's excise duty reserved for public benefit.

On the east side of the Technical Institute in Romford Road, the Passmore Edwards Museum was opened by Daisy, Countess of Warwick in 1900. This housed the collections of natural history and archaeological material from the Essex Field Club. The museum passed to Newham Council but was closed in 1994. The building was later turned into the Students' Union by 2003.

The West Ham Central Library, later Stratford Library, has been replaced by a new library in The Grove, the old premises becoming the Learning Resources Centre for the University of East London by 2003.

A general view of the building with the Romford Road frontage and Water Lane leading off on the left.

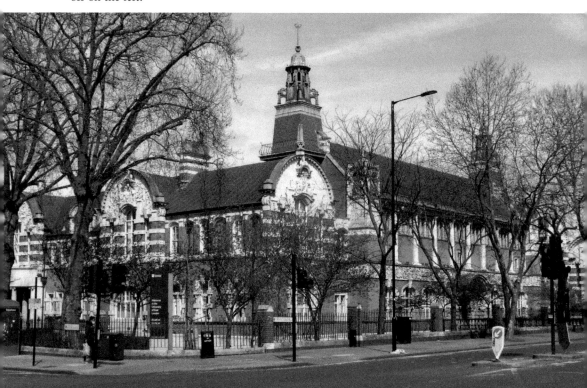

Left: The Romford Road entrance. The inscription either side of the borough coat of arms has now been changed to read University of East London.

Below: The former Passmore Edwards Museum.

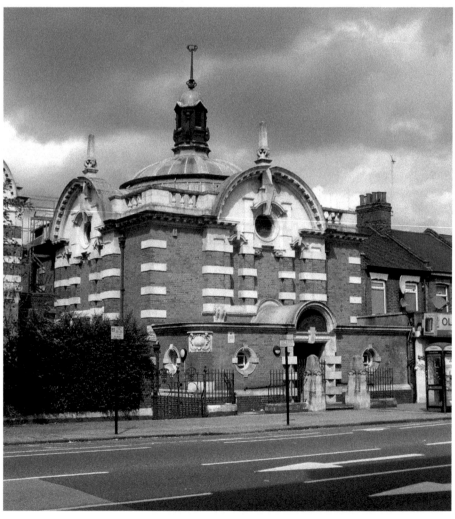

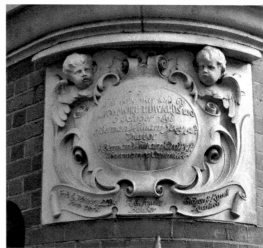

Above left: The decorative panel above the entrance door to the former museum.

Above right: The commemorative plaque on the side of the museum building that was laid by J. Passmore Edwards.

Right: The Water Lane entrance, formerly the library entrance.

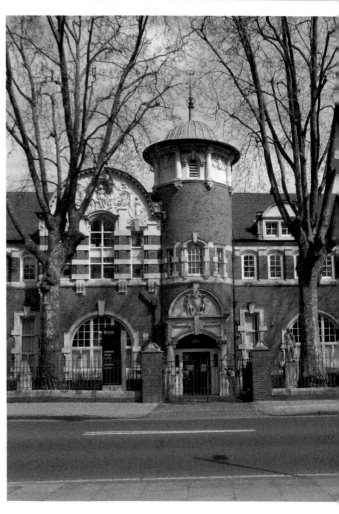

19. East Ham Memorial Hospital, Shrewsbury Road, E7

The East Ham Hospital was opened in 1902 as a voluntary cottage hospital with twenty beds, being financially supported by John Passmore Edwards to the tune of £5,000. The original design was by Sylvanus Trevail. An out-patients department opened in 1904. It was extended in 1915 to twenty-five beds, becoming the Passmore Edwards East Ham Hospital. During the First World War it became an army hospital.

Following the war an appeal was launched in 1919 to raise funds to build a general hospital. A new two-storey hospital building, consisting of three blocks to designs by Mennie and Smith, was erected on an adjoining site and opened by Queen Mary in 1929. There were now 100 beds, eighty in the new building and twenty in the former building, now children's wards. The hospital was renamed the East Ham Memorial Hospital in memory of the servicemen killed in the First World War.

Until 1929 many of the hospitals in London were administered by either the Poor Law Unions or the Metropolitan Asylums Board. However, the Poor Law Unions were abolished under the Local Government Act 1929 and their powers transferred to County and County Borough councils. The Metropolitan Asylum Board was dissolved in 1930. East Ham and West Ham became responsible for the hospitals in their areas.

A general view of the 1929 buildings.

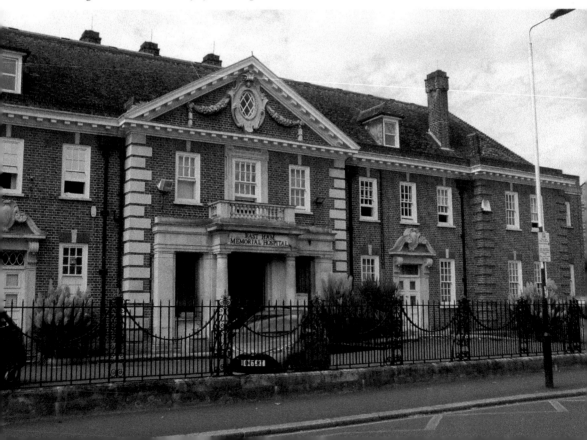

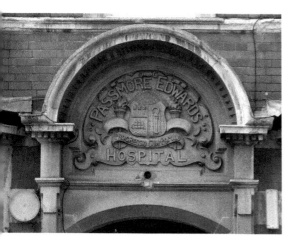

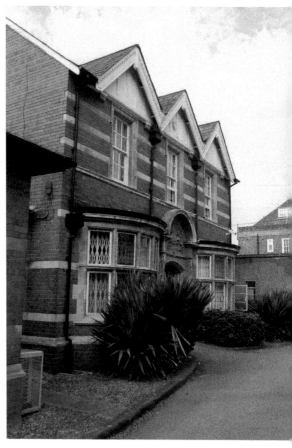

Above: The Passmore Edwards building doorway with the East Ham coat of arms.

Right: The Passmore Edwards building.

With the creation of the National Health Service from 5 July 1948, ownership passed to the NHS, becoming part of the North East Metropolitan Regional Hospital Board.

Many of its functions have now been transferred to the Newham University Hospital in Glen Road, Custom House, which opened in December 1983. But the site remains in use by the National Health Service. In 1990 it reopened with eighty-seven beds for acute psychiatric and psychogeriatric patients and in 2007 a new purpose-built care centre opened behind the site which has become part of the East Ham Care Centre.

2c. Atherton Leisure Centre, 189 Romford Road, E15

A new state-of-the-art leisure centre opened in April 2016 replacing the former West Ham Baths. Built by Mullaley, the leisure centre includes a 25-metre six-lane pool and a 20-metre teaching pool. The teaching pool has an adjustable floor to vary the depth and a platform lift for disabled swimmers. Other facilities include a

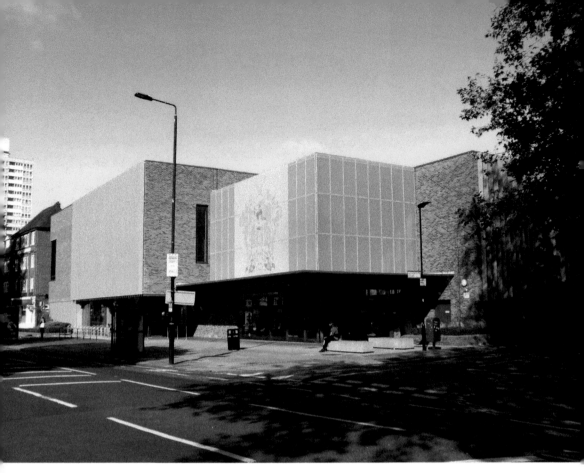

The Atherton Leisure Centre which replaced the former West Ham Baths.

gym with the latest exercise equipment, two fitness studios, a group cycling studio, café, crèche and soft play area. The then Newham Mayor, Sir Robin Wales, said, 'Our residents deserve a modern, accessible, state of the art centre. This is what we promised and this is exactly what we have delivered.'

Culture/Education/Recreation

21. Tate Institute, 1 Wythes Road, Royal Docks, E16

Following the establishment of Henry Tate's sugar refinery at Silvertown in 1878, the Tate Institute was opened in 1887 by Henry Tate at a cost of £5,000 to serve as a community centre 'for the benefit of the industrial classes of Silvertown and its neighbourhood'. Sir William Tate gave £1,500 to renovate the building in 1904 and another £1,200 in 1906. It was closed in 1933 and then bought by West Ham Council in 1937, who converted it into a public library and hall which opened in 1938. It served as an air-raid post during the war. The building was leased back to Tate & Lyle in 1953 as the Tate & Lyle (London) Sports & Social Club, with the upper floor remaining as Silvertown Library until 1961. By 2011 the building

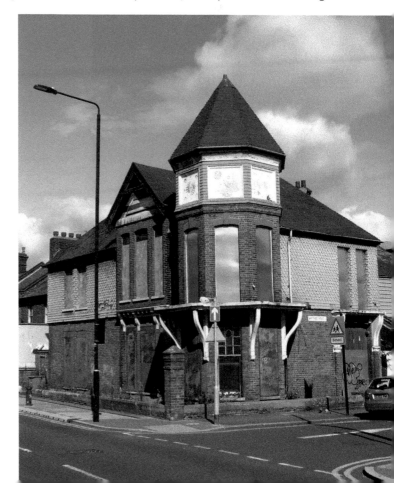

The Tate Institute
building in 2020.

was once again under Newham ownership and boarded up. An attempt to have the building given listed status was made in 2006 but was not successful. In 2016 a group of volunteers set up Craftory Workshops to revive the building as a site for up-cycling and up-skilling. This was in conjunction with the London Festival of Architecture 2019. When photographed in August 2020 it was boarded up and derelict once again and still the same in 2022.

22. Theatre Royal, Stratford, Gerry Raffles Square, E15

The origins of the Theatre Royal date from 1884 when it was commissioned by Charles Silver, an actor-manager. The architect was J. G. Buckle. It was originally intended to convert an existing workshop. The somewhat plain exterior was considered as ugly at the time. Inside was more ornate with plasterwork. The two galleries were supported on cast-iron columns and two boxes were provided, one on either side of the proscenium. In 1887 workshops and a dressing room were added on one side, and in 1891 the stage was extended backwards and a bar added. The building is listed Grade II.

The Theatre Royal became famous after 1953 with the residency of Joan Littlewood's Theatre Workshop, which produced a series of groundbreaking plays. She set out to smash the notion that theatre was only for and about the upper classes. Theatre Workshop's productions included *A Taste of Honey*, about an unmarried pregnant teenager, *Oh What a Lovely War!* and *Sparrows Can't*

The exterior of the Theatre Royal, Stratford.

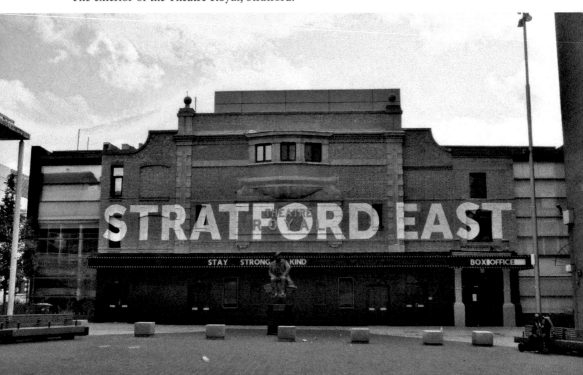

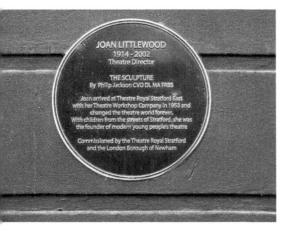

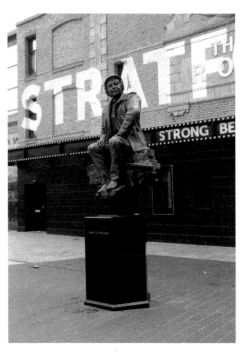

Above: The plaque explaining the statue and commemorating Joan Littlewood.

Right: The statue of Joan Littlewood (1914–2002) outside the theatre.

Sing. Working with local children, she became the founder of modern young people's theatre.

The Theatre Royal remains as one of London's few live provincial theatres outside the West End. It is referred to as Stratford East, to distinguish it from that other more famous theatrical town, Stratford-upon Avon.

23. St Marks, Silvertown/Brick Lane Music Hall, 443 North Woolwich Road, E16

This church owes its origins to an investigation, following a cholera epidemic, into the poverty and poor living conditions of the people of the Hallsville neighbourhood (as the area was then known). The Reverend H. Douglas appealed through the columns of *The Times* in 1859–60 for funds to provide an architectural, as well as spiritual, beacon for the area. The site was given by the dock company.

The church was designed by Samuel Saunders Teulon and built between 1861 and 1862. This was one of three London churches he designed. The church is mainly in yellow brick with a tower and slate roof. There is a circular stair turret. It can be said to have a certain 'Marmite' appearance – you either love it or hate it. It certainly made its presence known amongst the contemporary surroundings of the docks and factories. Pevsner was less than complimentary: '1861–2 by

S. S. Teulon. As horrid as only he can be and yet of a pathetic self-assertion in its surroundings ...'. Ian Nairn also described it thus: 'A hard punch right in the guts. Sombre and compact brooding over the bizarre landscape of funnels rather than tree-tops. Teulon's style has stopped being merely original, has become fused into glittering poetry, all knobbly with harsh polysyllables ... an architectural imagination the size of Blake's'.

By 1971 it was still in use but considered for redundancy, and then closed in 1974. It was then badly damaged by fire in 1981. This destroyed the original hammerbeam roof, but this was restored along with the rest of the building by 1989. Now no longer in use as a church, it was considered at the time as a suitable place to house the Passmore Edwards Museum's Victorian collections. However, instead it has become the Brick Lane Music Hall.

This was the vision of Vincent Hayes. A former performer, during the 1980s he offered music hall entertainment in the Lord Hood public house, Bethnal Green. In 1992 he created a music hall in the workers' canteen of the former Truman's Brewery. Then in 2003 he took over the recently restored but vacant former church, adapting it for its new role. In 2012 English Heritage awarded a Grade II* listing, citing the consideration taken to preserve the integrity of the building. The war memorial in the grounds also has a Grade II listing. In 2013 Vincent was awarded the MBE for his services to British Music Hall.

St Marks in August 2020.

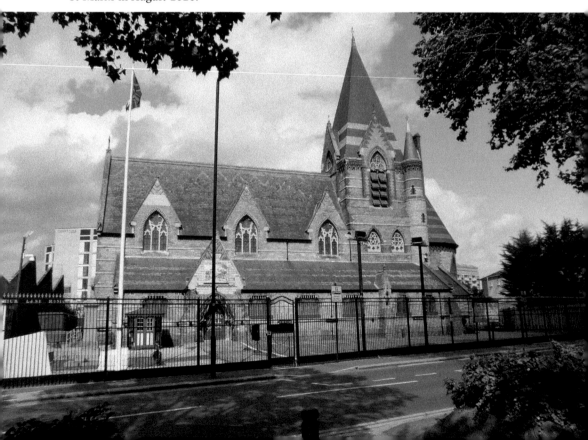

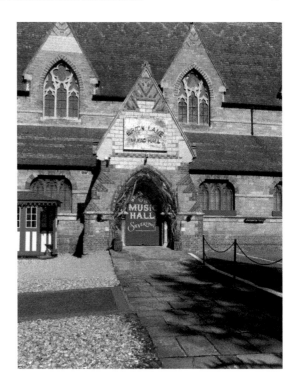

Details of the entrance door.

24. Spotted Dog Public House, Upton Lane, E7

This is the oldest non-religious building in Newham and is reputed to have originated as a Tudor hunting lodge or kennels. It was used as a meeting place during the outbreak of plague in the early seventeenth century. It was converted to a public house, possibly in the early 1800s as it is shown on a map of 1821 as 'The Dog'. Although much rebuilt externally, the oldest parts are in the south side with early timbers in the porch and the Old Dog Bar contained a Georgian fireplace and oven. Later extended, it became a popular haunt of visitors. It also attracted sporting fans from the Clapton FC amateur football club, established in 1878 and who moved to the adjacent football ground in 1887. In 2020 the supporter-owned Clapton Community Football Club bought the leasehold of the football ground from the freeholder, Heineken Brewery. The pub was given Grade II listing in 1950. The trees surrounding it have been the subject of a Tree Preservation Order since 1971.

Unfortunately, like many of Newham's public houses it closed, in 2005, and has been derelict since then. In September 2020 it was in a sorry state, boarded up and attracting the attention of fly-tippers. In 2020 planning permission was granted for its restoration and conversion to a boutique hotel, but with the collapse of the hospitality industry as a result of the Covid-19 lockdown no work had taken place by 2022.

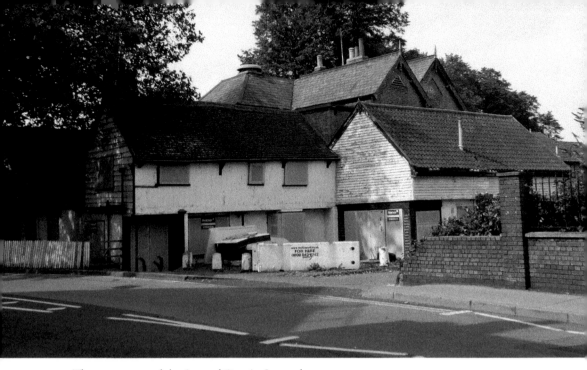

The sorry state of the Spotted Dog in September 2020.

25. King Edward VII Public House, Stratford Broadway, E15

This old public house, sited between taller buildings on the south side of Stratford Broadway, probably dates back to the mid-eighteenth century. It used to be named The King of Prussia, commemorating Frederick the Great (1740–86). However, in 1914 with the outbreak of the First World War it was patriotically renamed King Edward VII.

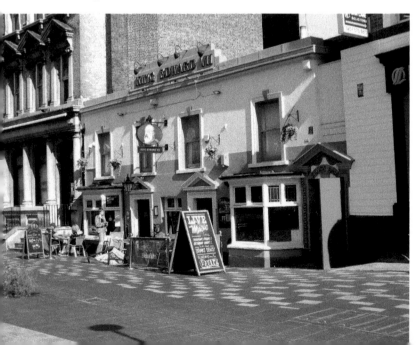

The public house stands out between the higher buildings on either side.

26. Plaistow YMCA, Greengate Street, E13

This impressive-looking five-storey building in Greengate Street was built in 1921 for the Young Men's Christian Association (YMCA) as a club. It later became part of the Polytechnic of East London. This in turn was redesignated as the University of East London in 1992. With the opening of the new campus in Docklands in 1999 this site became redundant and was sold off for conversion to flats. The exterior remains largely original. It is built of white brick with a stone plinth. The style of the roof logo and lettering gave rise to its name as the Red Triangle Club.

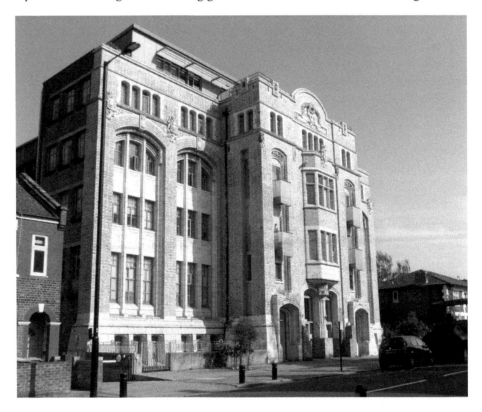

Above: The frontage of the Plaistow YMCA.

Right: The roof logo with its red triangle sign.

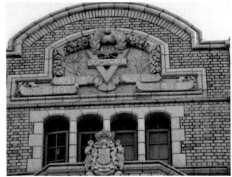

Public Utilities

27. Abbey Mills Pumping Station, Abbey Lane, E15

Abbey Mills pumping station was built to raise the sewage nearly 40 feet from the two Low Level sewers which join here to the Northern Outfall Sewer. It was completed in 1868 to the design of architect Charles Driver (1832–1900). It was built on the former lands of Stratford's Langthorne Abbey – hence the name. The highly ornamental design is in a mixture of architectural styles including Italian Venetian, French Gothic and Byzantine and has the layout of a Greek cross. The result was described as 'The Cathedral of Sewage'. The cost of construction was £200,000 out of a total of £3 million for the whole sewer system. The original steam beam engines were replaced by electric pumps in 1933. Coal for fuelling the steam engines was brought by barge along the nearby Channelsea River. The two redundant chimneys were removed in 1941 for fear that they might be bombed and the resulting damage disable the pumping station. Still owned by Thames Water, since a new pumping station was completed in 1997 this serves now only as a standby to deal with storm flows.

Abbey Mills in the 1930s before the chimneys were removed. (Reg Batten)

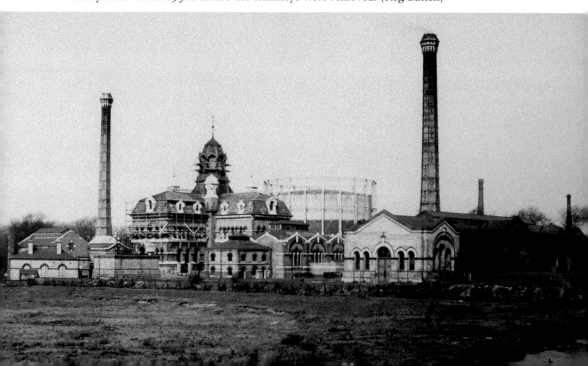

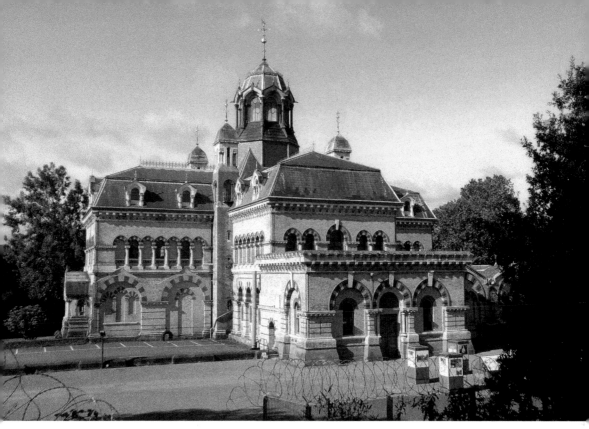

Above: Abbey Mills viewed from the Greenway. The pumping station is listed Grade II*.

Below: One of the stumps from where the chimneys were removed.

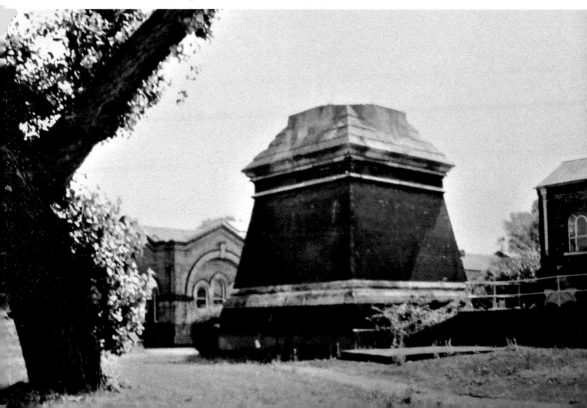

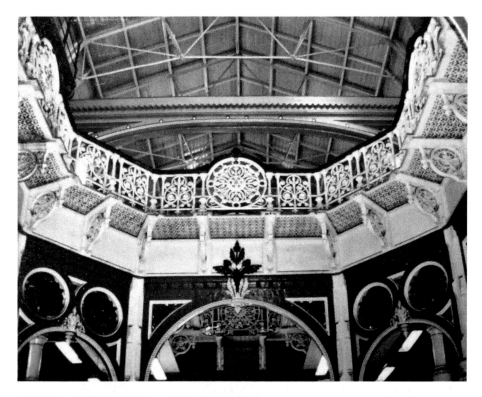

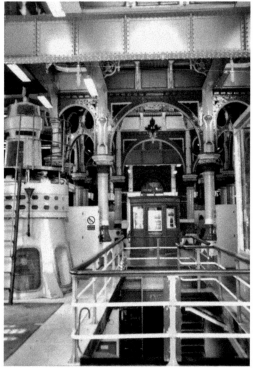

Above: A view inside the engine house showing some of the elaborate ornamentation, viewed in 2003. The paintwork was originally more elaborate – printed boards have been put in place to show the original designs.

Left: Electric pumps have replaced the original beam engines.

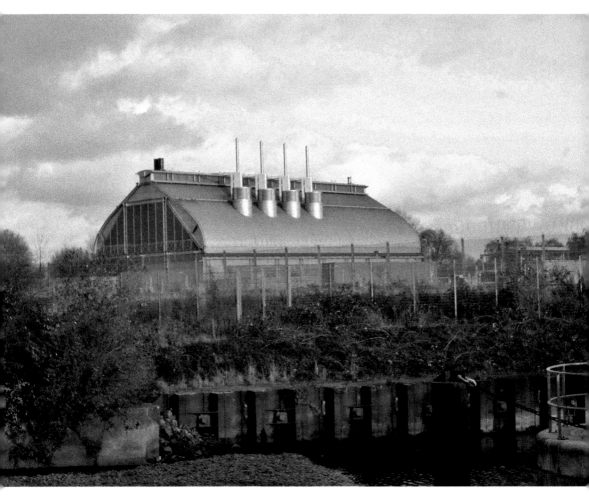

A huge contrast in architectural styles is presented by the new Abbey Mills pumping station designed by Allies & Morrison and opened in 1997. This raises sewage between the two Low Level sewers and the Northern Outfall Sewer. The Lea Tunnel, completed in 2016, connects Abbey Mills to Beckton Sewage Works, thus removing the need to dump overflow sewage into the Lea.

Places of Worship

St John's was built by Edward Blore in 1832–34 as a chapel of ease to accommodate the growing population of Stratford, and is now the parish church for Stratford which became a separate parish from West Ham in 1844. The naturalist and social reformer Antonio Brady was buried in the churchyard in 1881, and an extension to the chancel in his memory was constructed in 1884. The crypt was used as an air-raid shelter during the Second World War. In 1998 a new room for community use was built on the north side in a complimentary style.

Below left: The Grade II St John's Church and its churchyard stand at the centre of Stratford Broadway. Until recently this formed a traffic island, but the road on the north side has now been pedestrianised.

Below right: The Martyr's Memorial which stands in front of the church commemorates eighteen Protestant martyrs including thirteen who were burnt at the stake on Stratford Green on 27 June 1556. The monument was erected in 1879. Designed by J. T. Newman, it stands 65 feet high and is hexagonal in shape, of stone and terracotta on a solid pedestal. It is surmounted by a projecting canopy and ribbed spire.

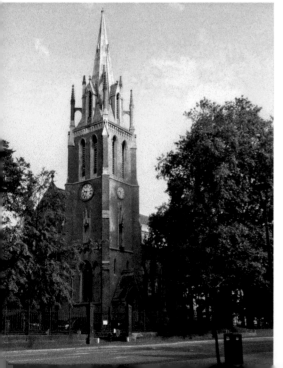
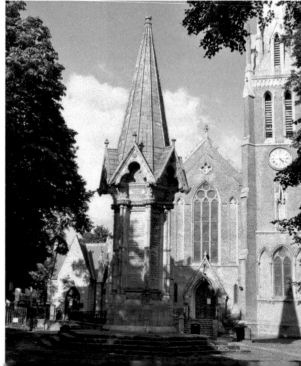

29. All Saints Church, Church Street, E15

West Ham parish church of All Saints was originally built in around 1180 but has been much rebuilt and enlarged since. It was enlarged in the thirteenth century; the tower, which is 74 feet high was added in the fifteenth century, and the broad aisles added in the sixteenth century. Further restoration took place in Victorian times, with Sir Giles Gilbert Scott designing the ornate reredos in 1866. The church has several monuments inside including those to Sir Thomas Foot (d. 1688) and Sir Thomas Smyth, both former Lord Mayors of London. The church has been Grade I listed since 1984.

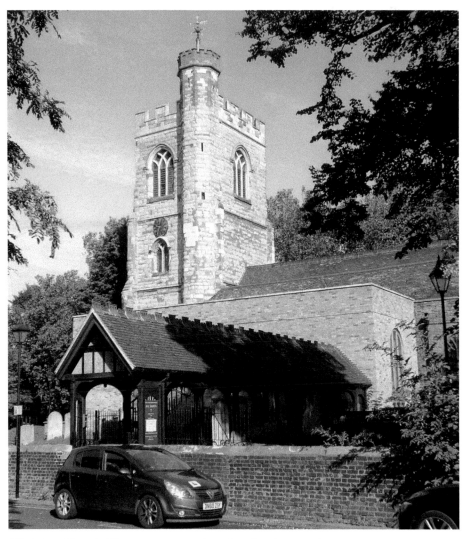

All Saints Church. The trees surrounding the church are subject to a Tree Preservation Order.

30. St Mary Magdalene's Church, 1 Norman Road, E6

Serving as a parish church for East Ham, this is the oldest Norman church in London still in weekly use. East Ham Parish Church of St Mary Magdalene dates back to the twelfth century, and although much renewed since, retains more of its original Norman features than any other in London – hence its Grade I listing. The side windows and west door are Norman. The tower is early sixteenth century, and the nave windows are from a restoration of 1844–45. There are brasses to Hester Neve (d. 1610) and Elizabeth Heigham (d. 1622) whose husband donated the font in 1639. There is a standing wall-monument to Edward Neville, Earl of Westmorland, dating from the early seventeenth century and surrounded by the original iron railings. The churchyard covers a vast 10 acres and is now a nature reserve, having been mostly closed to burials in 1973. Amongst the graves is that of the antiquarian William Stukeley (d. 1765). The church itself is largely hidden from view by the extent of trees, except for the angles seen here.

The north side of the church.

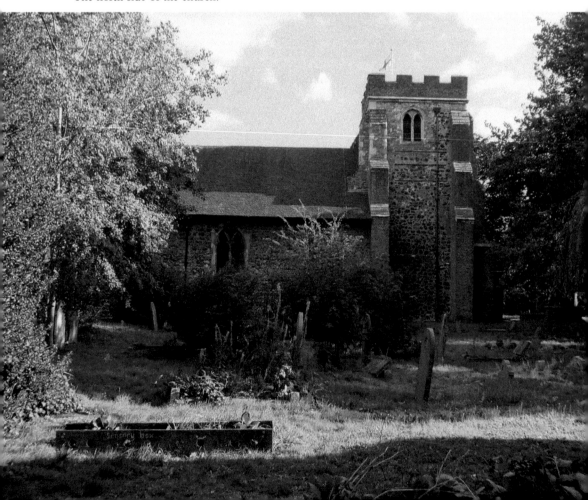

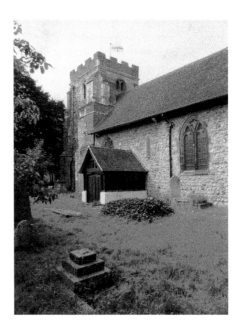

The south side with porch.

31. St Mary's Church, Little Ilford, Church Road, E12

This small Grade I listed church dates back to the twelfth century; the nave and one window are of this period. The chancel was rebuilt and a south porch and family chapel to the Lethieullier family added in 1724 which contains monuments to family members of the eighteenth century. Archaeologists have discovered evidence that it may have replaced an older wooden church on the same site. It remained a parish church until 1938 but is now a chapel of ease to St Michael's Church, Romford Road.

St Mary's Church, Little Ilford.

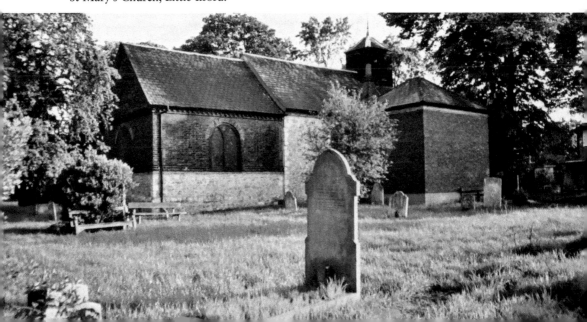

32. London Sri Mahalakshmi Hindu Temple, 241 High Street North, E12

Situated on the corner of Plashet Grove and High Street North, this makes a somewhat incongruous sight alongside the Victorian terraces of shops that otherwise occupy the area. The temple is on the site of a former public house, the Burnell Arms. This area of Newham is much inhabited by people of Indian background, and many of the nearby shops are Indian restaurants, jewellers or sell Asian produce. The new temple replaced a previous building in repurposed business premises that had been in use since 1990. The new temple building is based upon the application of sustainable technologies. It is of concrete construction with granite flooring, central heating, and central air conditioning. The construction of the whole temple and Rajagopuram entrance in Chola style was under the direct supervision of Padmashri Silpakalamani Muthiah Sthapati, a famous Hindu temple architect from India. The sacred images were sculpted in India in white granite by eminent Indian sculptors. Conforming to the South Indian tradition, the tower (or *rajagopuram*) is over the entrance which faces east. Conveniently, this gives the temple a commanding presence on the High Street. Much of the cost of the project was met by crowdfunding and donations.

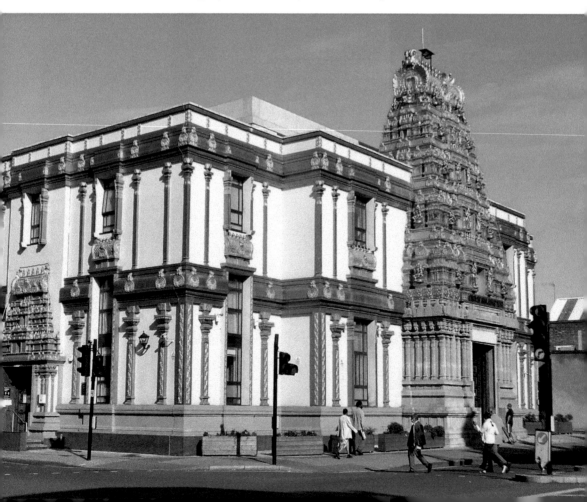

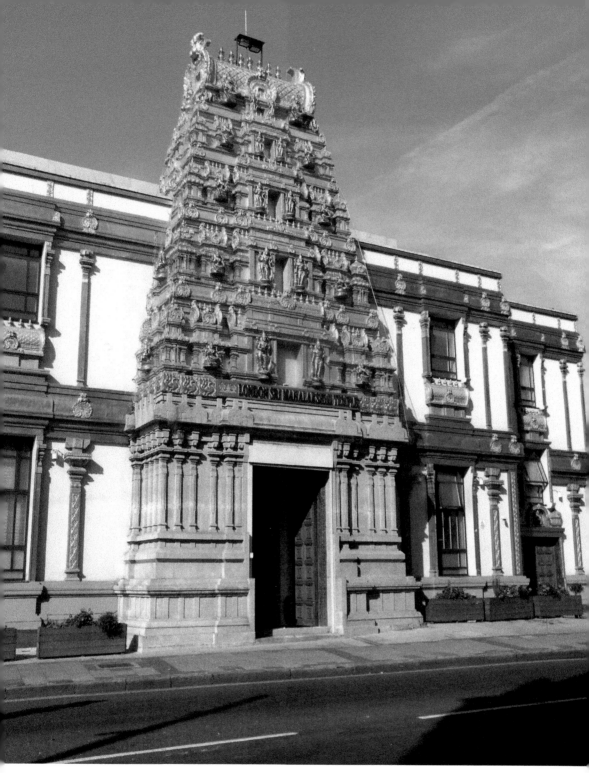

Above: Details of the tower or rajagopuram.

Opposite: The imposing site of the London Sri Mahalakshmi Temple.

Housing

33. The Red House, Upton Avenue, E7

This house was built in the eighteenth century and was the home of a Dutch merchant in 1717. It was one of a number of large houses constructed around this time in the villages of Plaistow and Upton as the country retreats for rich city merchants and businessmen, but is the only survivor of these. It was later owned by a Mr George Tuthill from 1871 until his death in 1887. He started out as a travelling showman but became the manufacturer of early trade union banners from 1837 onwards. His company became the world's leading maker of these silk banners. The Red House was extensively reconstructed in 1880. The main façade is surmounted by a balustrade with fourteen ornamental urns and a decorative gable. There are six mock-Tudor chimney pots. This is no longer in residential use as it is now owned by the St Antony's Catholic Club. The St Antony's Catholic Church was built in the nineteenth century to cater for the Irish Catholic community living in the area at that time. The Red House has a Grade II listing.

The Red House on Upton Avenue.

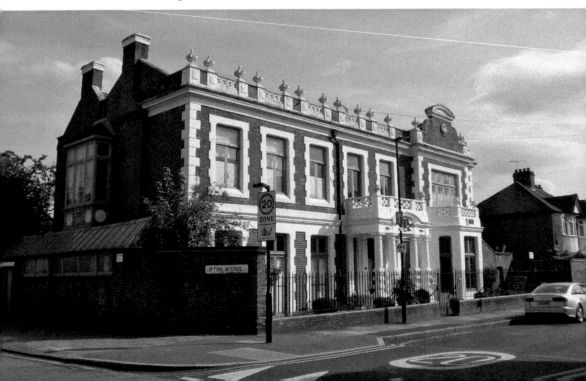

Details over the porch of
the Red House.

34. Meggs Almshouses, 271–275 Upton Lane, E7

The almshouses were built in 1893 by the Whitechapel parish to replace the
original dwellings which were in Whitechapel Road. The site had been chosen by
the Rector and Churchwarden of Whitechapel, who were trustees of the charity
established by William Meggs, a seventeenth-century rich London merchant. Now
owned by the Meggs Almshouse Charity, there are twelve one-bedroom retirement
flats with a communal lounge, laundry and garden. Applicants must be residents
of either Newham or Tower Hamlets.

A general view of the almshouses.

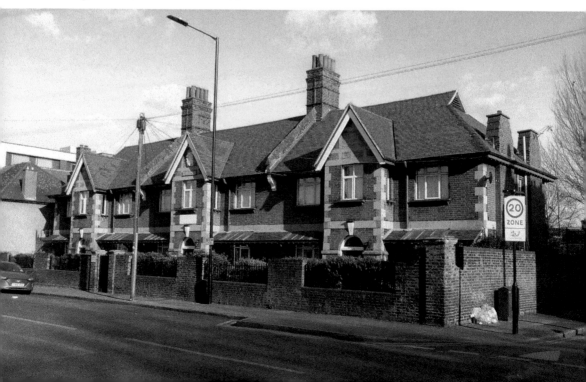

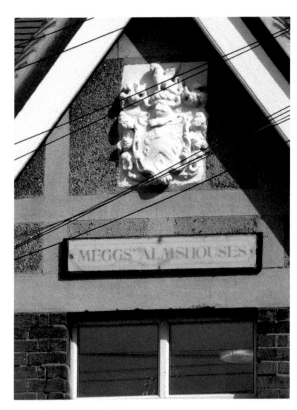

Left: Above the central doorway are mounted the arms of the Meggs family and the memorial stone.

Below: The memorial stone. On the left it reads: *The original almshouses under the will of Williams Meggs Esq were erected in the Whitechapel Road in 1658.* On the right: *The memorial stone of this building was laid by Mrs Sanders wife of the Rector on the 20th day of July 1893* followed by a list of trustees.

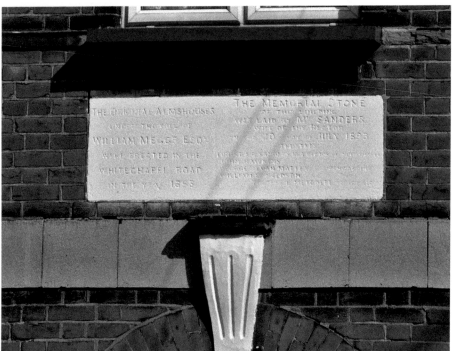

Transport

Stratford was first served by rail when the first section of the Eastern Counties Railway opened in 1839. This later merged with other railways to become the Great Eastern Railway in 1862, the main railway company serving East Anglia. Services terminated in London at Shoreditch from 1840 (renamed Bishopgate in 1846). The present terminus at Liverpool Street did not open until 1874. Stratford became a junction as early as 1840 when the Northern & Eastern Railway line from Broxbourne joined here. A line to North Woolwich was opened in 1847 and another to Loughton in 1856, later extending to Epping and Ongar. The low-level platforms was opened in 1854 as part of a link extending the North Woolwich line northwards to connect with the North London Railway at Victoria Park.

Stratford station was rebuilt in the late 1930s as a result of the New Works Programme, a government series of public investment projects partly to relieve unemployment in the Depression. Under this scheme the local services to Shenfield were electrified. Also under the New Works Programme, the route from Stratford to Epping and Ongar and the Hainault loop were transferred to London Transport to become an extension to the Central line which had previously only run as far east as Liverpool Street. New platforms were constructed for the suburban services and Central line, although delays caused by the Second World War meant that the Central line did not reach Stratford until 1946 and suburban electric started from 26 September 1949.

The line from Stratford to Dalston, which had lost its passenger services in 1944, was reopened in 1979 with new stations at Hackney Wick and Hackney Central in 1980, Dalston Kingsland in 1983 and Homerton in 1985. This was later electrified along with the North Woolwich line and became a through electric service from North Woolwich to Richmond, serving the low-level platforms.

The next addition to Stratford's railway network was the Docklands Light Railway, the first section of which opened in 1987. This terminated at the vacant bay platform No. 4 which along with platform 7 had been installed for a shuttle service to Fenchurch Street that never materialised.

A new Stratford station building designed by Wilkinson Eyre opened on 14 May 1999, a fitting building for this location's increasingly important role as an interchange. In the same year the station gained another new Underground line – the Jubilee Line Extension from Green Park via Docklands, which opened

just in time to serve the Millennium Exhibition at the new Millennium Dome at North Greenwich (since renamed the O2 Arena).

Stratford had also been home to the GER works, the largest locomotive depot in the country and extensive freight yards and sidings. All had closed by 2000 and it was this vast extent of largely redundant land that made Stratford the ideal location for London's Olympic bid venue. With the successful award of the 2012 Olympic Games, Stratford station became of strategic importance and a massive total of £102.5 million was put aside for enhancements to increase capacity. Amongst this, new platforms were provided for the North London Link services, now operated as part of the London Overground. The North Woolwich line closed in 2006 as it was replaced by a new DLR line via London City Airport, later extended to Woolwich Arsenal; but the section from Canning Town to Stratford became another DLR line extended to the new Stratford International station. This opened in 2011 north of the main station and is on the HS1 high-speed line. Despite the name it has never been served by Eurostar services but is used by SouthEastern high-speed services to Kent.

The Westfield Shopping Centre is situated adjacent to Stratford station and Stratford City bus station. A new concourse entrance to the station was created to serve both it and the whole Stratford City area north of the railway. A pedestrian overbridge was also built to span the rail lines across to Stratford bus station and the shops, market and other facilities to the south of the railway.

The new Stratford station opened in 1999. This view was taken on 6 March 2005 and shows the 'Back the Bid' branding applied as Britain lobbied (successfully) to stage the 2012 Olympic and Paralympic Games.

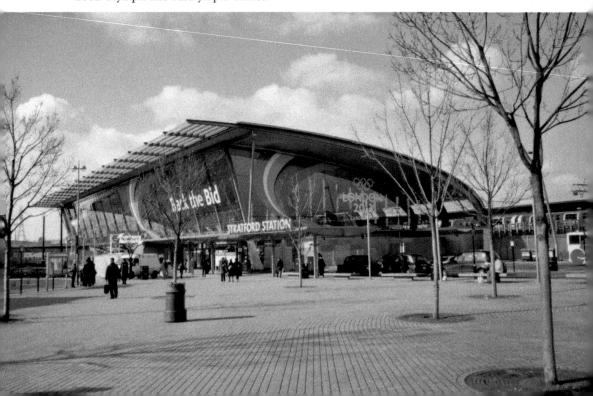

Before Covid, Stratford was the busiest station on the Underground outside the Central Area Zone 1. However, in November 2021 the *Metro* newspaper reported that Stratford had overtaken Waterloo as Britain's busiest railway station, a title it had held for seventeen years. An estimated 14 million passengers travelled though Stratford in the year to 31 March according to the Office of Rail and Road. With the opening of the Elizabeth Line (aka Crossrail) in stages from 24 May 2022 the station will only grow in importance as the Shenfield–Liverpool Street service has become part of the new Elizabeth Line network.

Following an initial consultation in 2021, in October 2022 the London Legacy Development Corporation announced a new set of proposals and consultations aimed at long-term improvements to the station area. Ideas being mooted include a new bridge to the Queen Elizabeth Olympic Park, a new direct link from Carpenters Estate, a new Southern Ticket Hall, new homes, retail and community spaces, etc. The transformation could take at least ten years at a cost anywhere from £330 million to £1 billion. They say 'This is a critical project which will benefit not only local people, but all those across the east and southeast of London who rely on Stratford station as a major interchange and destination in its own right.' Details are available at www.stratfordstation.commonplace.is.

Stratford station gained an extension to the east with additional ticketing facilities and access directly to the footbridge that was built across the railway to Westfield and the Olympic site.

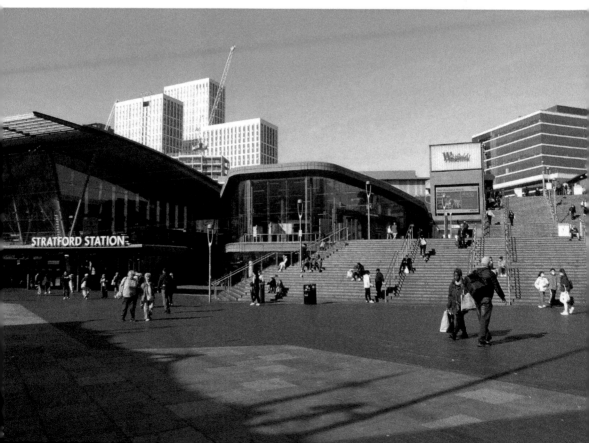

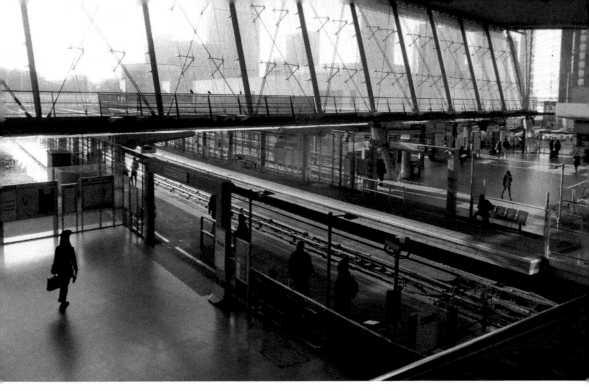

Above: A view inside the concourse. The low-level platforms originally for the North Woolwich line and now used by the Docklands Light Railway run at right angles to the main London-bound platforms. Beyond these are the three platforms for the Jubilee Line.

Below: The canopies for the two platforms (both numbered 4), now provided for the Docklands Light Railways' original route, are in a completely differing style to the rest of the station.

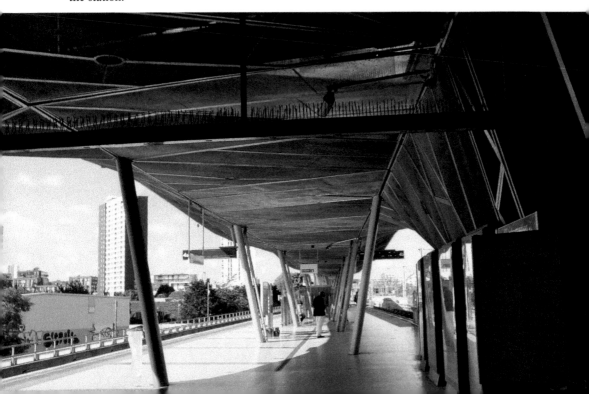

36. Stratford Market Station/Stratford High Street Station, Stratford High
 Street, E15

This station was originally opened as Stratford Bridge on 14 June 1847 on the
new line from Stratford to North Woolwich. It was rebuilt in 1860. In 1879 the
Great Eastern Railway opened a vegetable market south of the station which was
then renamed Stratford Market from 1 November 1880. A further rebuilding to
add two additional freight tracks and a new street-level building was completed
in 1892. In 1893 a new GER printing works was constructed alongside and
connected to the station by elevated walkways (*see* p. 28). The station was formerly
well-used because the trains from North Woolwich to London's Fenchurch Street
or Liverpool Street stations turned off before the main Stratford station and did
not serve this. However, patronage dropped off after these services ceased in
1940 and the station closed in May 1957. The platforms and their canopies were
demolished but the station building remained. The Jubilee Line Extension took the
by then redundant freight tracks when it opened in 1999. The North Woolwich
line closed in 2006 but the section from Stratford to Canning Town became a new
section of the Docklands Light Railway. Stratford Market station was converted
into commercial premises in the late 1960s and saw various uses over the years. In
1994 Newham Council, recognising its historical importance, approved a scheme
for its restoration. With the new Stratford extension it reopened as a DLR station
named Stratford High Street in 2011. The building itself remains in commercial
use – like other DLR stations there is no ticket office.

Stratford High Street station, September 2011.

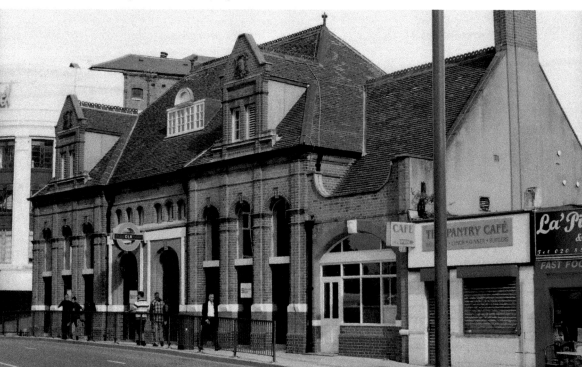

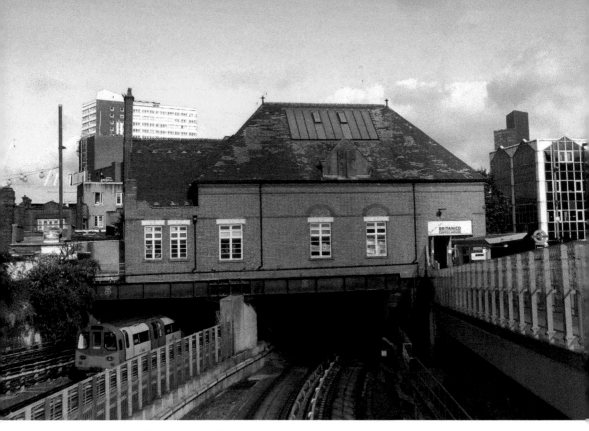

The platform side of the building in 2020.

37. Stratford Bus Station, E15

Stratford bus station opened on 16 November 1994 and replaced an older bus station on the same site, a dark, draughty location which was situated below a multi-story car park. The new bus station was designed in-house by London Transport architect Soji Abass and has five bus stands. The bus station features twenty-two steel columns, arranged in two rows. Each column supports an inverted, square-based cone drawing downwards to its narrowest point. The canopy is made of TFE-coated glass fibre fabric, the same material used to make the canopy of the Millennium Dome. The bus station's canopy is suspended and kept taut from above, via metal cross beams and a set of cables running out from the steel pillars, which extend above the top of the canopy. Rain falling on the canopy is collected and drains down through the columns. The canopy is lit by uplighters clustered around the columns. There are waiting shelters and an enquiry office, but other facilities are minimal and the public toilets were soon closed.

There is another smaller bus station on the Westfield (north) side of the railway which opened in September 2011. The area here has been given the rather grandiose-sounding title of 'Stratford City' – hence this is 'Stratford City Bus Station'.

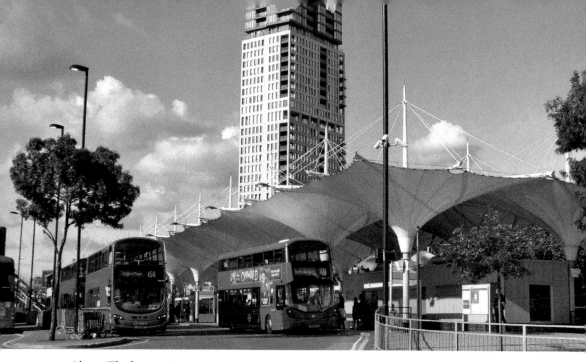

Above: The bus station in 2020.

Below: The bus station seen from the steps of the bridge across to the Westfield Shopping Centre (*see* p. 67). The leaf-like sculpture installation to the left of the bus station is called the Stratford Shoal. Unveiled in 2012, it is 250 metres long and features seventy-three titanium leaves that move in the wind and change colour according to the amount of light. It was designed by Studio Egret West.

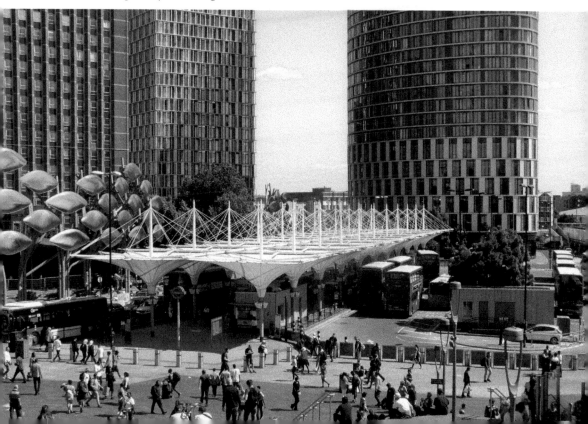

38. Canning Town Station, Silvertown Way, E16

This used to be just a station on the Stratford–North Woolwich line. With the advent of the Beckton branch of the DLR it became an interchange with a new station built on a different site. The first part serving the North Woolwich line opened in 1995 with the DLR platforms following in 1998, which were built at an upper level above the platforms for the Jubilee Line extension then being constructed. This was opened in 1999. The station is linked to a new bus station alongside, also opened in 1999. After the North Woolwich line closed in 2006, the line from Stratford and former platforms are now used by the DLR line from Stratford International–Woolwich Arsenal. The flyover built south of the station allows DLR trains from either the high- or low-level platforms to access both the Beckton and Woolwich Arsenal routes.

There is an inscription by the side of the stairway going down from the entrance in Silvertown Way to the below-ground ticket hall which commemorates the Thames Ironworks. They were one of the last large shipbuilding works on the

Platform view. A DLR train from Woolwich Arsenal to Stratford International departs from low-level platform 2, with a southbound Jubilee Line train in the adjacent platform. The high-level DLR lines run above the Jubilee Line. September 2019.

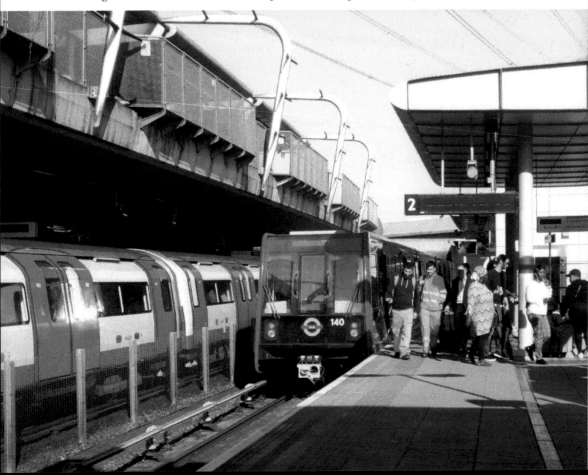

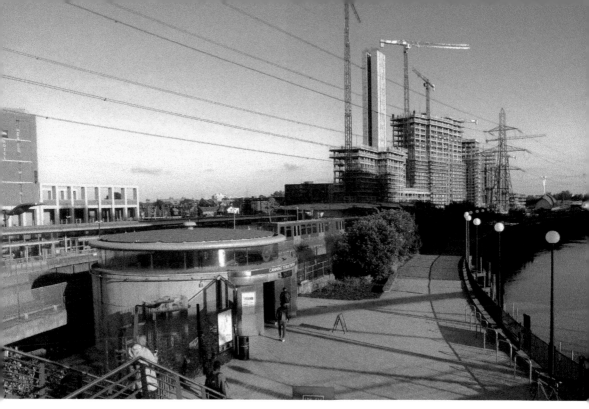

This view of Canning Town, taken from the footbridge across Bow Creek, shows a DLR train at the high-level platforms. The Jubilee Line runs below, and the other DLR tracks and bus station are over to the left. Major building development is taking place locally, as can be seen by the construction work in the distance. September 2019.

Thames, situated in Bow Creek close to Canning Town station. Their production included a number of warships, of which one, HMS *Warrior*, survives and is preserved at Portsmouth Harbour. The company had a works football team, which developed into West Ham United.

39. North Woolwich Old Station, Pier Road, E16 (Also New)

The first section of a line south from Stratford was opened by the Eastern Counties & Thames Junction Railway in 1846 to bring seaborne coal traffic from the River Thames near Bow Creek. The line was extended to North Woolwich, opened on 14 June 1847, and was soon after purchased by the Eastern Counties Railway. Outside the station was a pier where the Eastern Counties Railway ferry took passengers across to South Woolwich. This ferry later closed on 30 September 1908, having been supplemented since 1889 by the London County Council's free ferry.

The Italianate-style North Woolwich station dates from 1854, replacing the original timber station. It was equipped with a turntable pit at the station end of the platforms.

The station was badly damaged by bombing on 7 September 1940. The canopy collapsed onto trains standing in the platforms and the station building was gutted. The station was eventually repaired, but with a new flat roof. The turntable was also replaced by points as a result of the war damage.

It was replaced by a new station alongside in 1979. The Grade II listed building then became a railway museum, opening in 1984 and being officially opened on Tuesday 20 November 1984 by HM Queen Elizabeth the Queen Mother who travelled from Stratford to North Woolwich hauled by the preserved A3 Pacific No. 4472 *Flying Scotsman*. But the good times did not last. The museum closed in 2008 and the building was boarded up. The railway has gone too, closed in 2006 when replaced by the Docklands Light Railway. Part of the track between Custom House and North Woolwich has now become a section of the Elizabeth Line, while the section from Canning Town to Stratford has become part of the Docklands Light Railway.

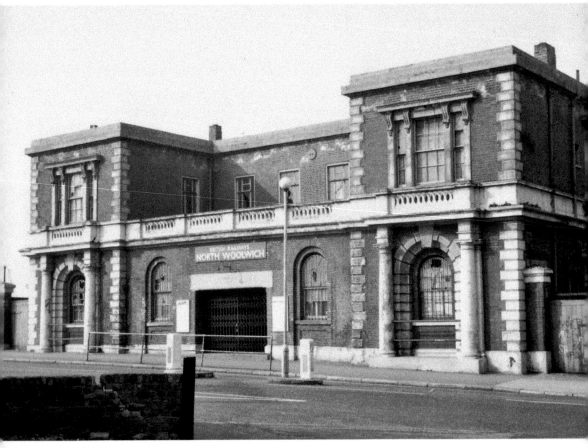

The station at its low point in the 1970s. The grilles are closed as there were no trains at weekends. Many of the windowpanes are broken and boarded up. Inside there was only a single track remaining as the goods yard had closed in December 1970.

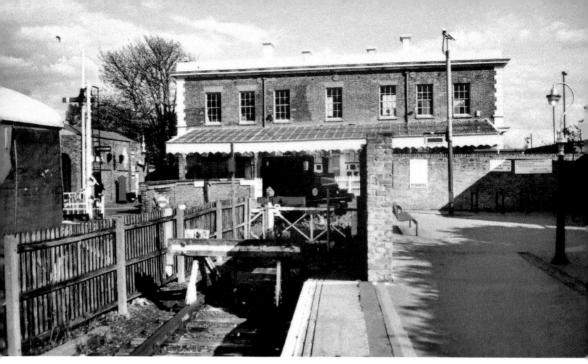

Above: The station platform side at the time when it was used as a museum. Trains used the platform from which the photograph is taken, with passengers exiting via the new station, just visible to the right of the lamp. The canopy was a restored copy with columns from Goodmayes station. In the former turntable pit, former Great Eastern Railway Y5 0-4-0ST No. 229 was exhibited.

Below: North Woolwich station in March 2022. After years of neglect it has recently gained a new tenant and been repainted externally. However, the canopy, platforms and tracks have gone.

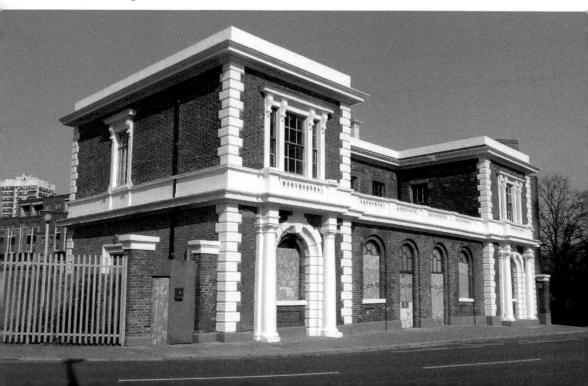

40. Jubilee Line, Stratford Market Depot, Burford Road, E15

A fruit and vegetable market was built in Burford Road by the Great Eastern Railway in 1897–81 on the Stratford–North Woolwich line. As built, there were approximately twenty-two warehouses, each 60 feet by 15 feet, a roadway 350 yards long and an arcade, partly glazed, some 40 feet wide. The covered area was around 3.5 acres. Construction was of lightweight cast and wrought iron clad in timber matchboard. To the north of this was a long four-storey warehouse building of brick construction with cast-iron windows. The market remained substantially unchanged until closure in 1991. This has since been demolished and the site is now part of the depot for the Jubilee Line Extension, opened in 1999.

Opened in March 1998, this was one of the first buildings to be completed on the Jubilee Line Extension (opened in 1999) and is the main depot for the Jubilee line stock. The design was put out to competition and was won by WilkinsonEyre Architects as their first major new-build project. Construction began in 1994. The brief called for a complex providing train maintenance and stabling facilities alongside extensive office and ancillary buildings. The building has a parallelogram shape with a space-frame roof. A 100-metre-wide, 190-metre-long arched roof covers eleven maintenance bays. The structure provides good daylight and 8 metres of clear headroom above the tracks. This is supported by tree-like

The interior of the Stratford Market Depot maintenance building. (M. Batten collection)

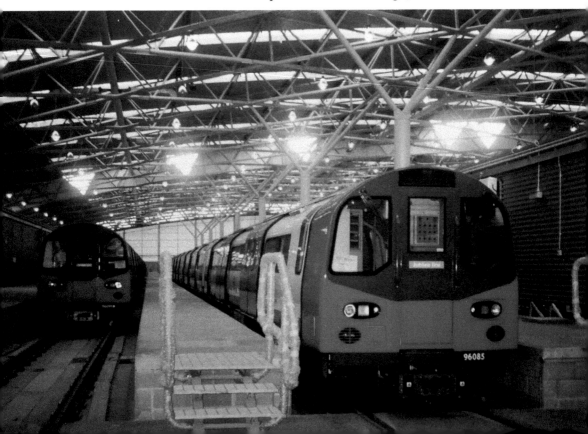

columns which spread the load onto the V-shaped supports at the perimeter and is cut with diagonal slit windows allowing sunlight to flood the space below. Outside there are thirty-three stabling roads. The main depot building was awarded a Civic Trust Award in 1998.

As well as the Jubilee line depot, a large training centre for London Underground is located at the site. This was opened by Tube Lines in 2005 as part of the Underground Public-private partnership.

The name of the depot commemorates the former wholesale fruit and vegetable market which was built by the Great Eastern Railway and occupied the site until closure in 1991.

41. West Ham Bus Garage, Stephenson Street, E15

Following the privatisation of London Buses in the 1990s, new companies Stagecoach and First Bus had opened garages in Waterden Road, Stratford. However, these had to close in 2008 as they came within the area they would be redeveloped as the Olympic Games site. A new site was found by the Olympic Delivery Authority for Stagecoach near West Ham station on land used formerly by Parcelforce. The new garage opened on 14 July 2010. It was the first completely new London bus garage for twenty years.

West Ham bus garage, taken at an Open Day in 2016.

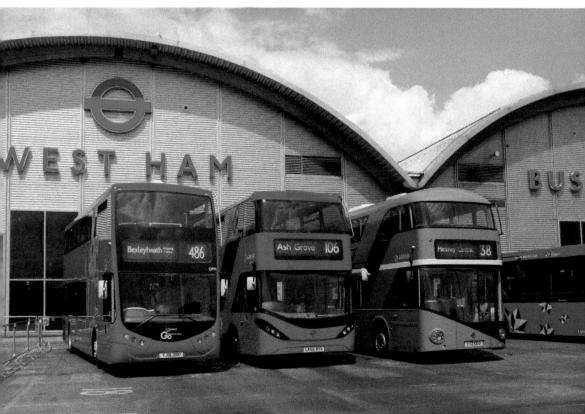

This has been designed with green credentials in mind, making it the most environmentally sustainable bus garage in the UK. If features rainwater harvesting, natural lighting and ventilation, and a 100kW wind turbine which meets 10 per cent of energy needs. The two central arches contain the engineering area with twenty-two pits. The open parking area has a capacity for up to 320 buses. It was designed by PRS Architects.

42. North Woolwich Foot Tunnel, Pier Road, E16

The Woolwich foot tunnel was opened in October 1912 to supplement the London County Council free ferry, and as an alternative at times when weather conditions prevented the ferry from operating. It was constructed at a cost of £87,000. It is 1,665 feet in length, lined with white tiles. The entrance shafts have a spiral staircase and a lift, previously attendant operated. That on the north bank descends 64 feet, on the south bank it is 51 feet. The tunnel roof is 38 feet below the water surface level at low tide and 69 feet at high tide. The engineer was Sir Maurice Fitzmaurice. The tunnel is open twenty-four hours a day. Cyclists are supposed to dismount and walk their cycles through, but as the tunnel is unstaffed few will observe this rule. The closure of the docks and the opening of the Docklands Light Railway through to Woolwich Arsenal station in January 2009 mean that the tunnel (and ferry) see fewer pedestrians than in the past.

The entrance shaft to the Woolwich foot tunnel at North Woolwich taken in April 1975. This still looks much the same, but the road layout/bus layby area was modified in 1998. Note that the streetlight to the left of the tunnel shaft is mounted on a former trolleybus pole.

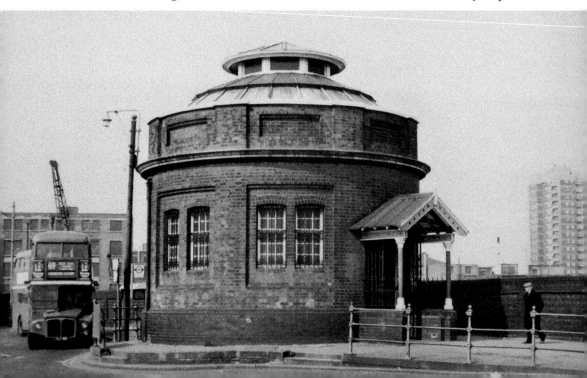

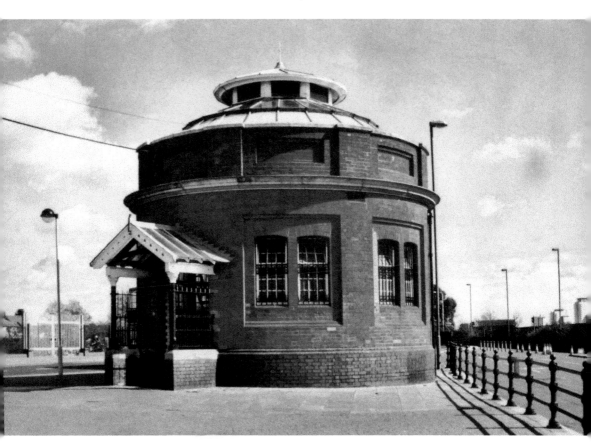

The foot tunnel now that the road layout has been amended.

Regeneration

43. University of East London Docklands Campus, University Way,
 Royal Docks, E16

The UEL Docklands Campus opened in 1999, London's first new university campus in over half a century. Building commenced in 1997 to a plan by Edward Cullinan Architects. It is located at Royal Albert Dock, which had closed to commercial shipping in 1981. The campus is directly served by the Docklands Light Railway's Cyprus station.

The University of East London main building.

The Halls of Residence with their unusual circular design. The angled roofs house solar panels.

44. London City Airport, Hartmann Road, Royal Docks, E16

The airport was first proposed in 1981 by Reg Ward, who was Chief Executive of the newly formed London Docklands Development Corporation (LDDC). He in turn discussed the proposal with chairman of John Mowlem & Co. Sir Philip Beck, and the idea of an airport for Docklands was born. By November of that year Mowlem and Bill Bryce of Brymon Airways had submitted an outline proposal to the LDDC for a Docklands STOL (short take-off and landing) airport.

On 27 June 1982 Brymon's Captain Harry Gee landed a de Havilland Canada Dash 7 turboprop aircraft on Heron Quays, in the nearby West India Docks, in order to demonstrate the feasibility of the STOLport project. Later that year the LDDC published a feasibility study; an opinion poll amongst local residents showed a majority in favour of the development of the airport, and Mowlem submitted an application for planning permission. A sixty-three-day planning inquiry started on 6 June 1983. By the middle of the following year, Nicholas Ridley, the Secretary of State for Transport, had indicated that he was 'disposed to agree the application', but asked for further details. The Greater London Council brought an action in the High Court of Justice to reopen the inquiry. After the High Court dismissed the action in March 1985, outline planning permission was granted in May of that year, followed by the grant of detailed planning permission in early 1986.

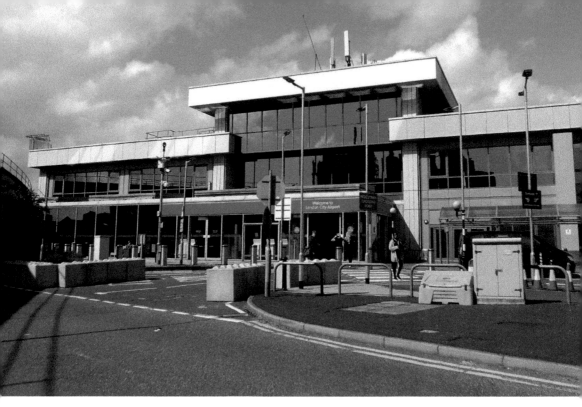

Above: The main passenger terminal building.

Below: Concrete decking has built over part of the former dock to provide turning space for aircraft as they prepare for take-off. A British Airways plane taxies on the runway. The building seen behind the plane's tail is 1000 Dockside, offices for the London Borough of Newham.

Construction began shortly after. Prince Charles laid the foundation stone of the terminal building, designed by R. Seifert and Partners, on 2 May 1986. The first aircraft landed on 31 May 1987, with the first commercial services operating from 26 October 1987. Queen Elizabeth II officially opened London City Airport in November of the same year.

There is a single, two-storey passenger terminal building with check-in desks on the ground floor. Corridors on the upper floor lead to the departure gates on the ground level. Since December 2005 the airport has been served by its own station on the Docklands Light Railway, which features an island platform with an overall roof and direct access to the terminal building.

45. Excel Exhibition Centre, 1 Western Gateway, Royal Docks, E16

This was opened in November 2000 on a 100-acre site on the north side of Royal Victoria Dock as an exhibition and international convention centre. It is owned by the Abu Dhabi National Exhibitions Company. Built at a cost of £550 million, it was designed by Moxley Architects and built by Sir Robert McAlpine. During the 2012 London Olympics it was the venue for seven Olympic and six Paralympic

The entrance to the ExCel Exhibition Centre is appropriately marked by the statue to the dockers, *Landed* (*see* p. 18), reminding visitors of the previous use of this site.

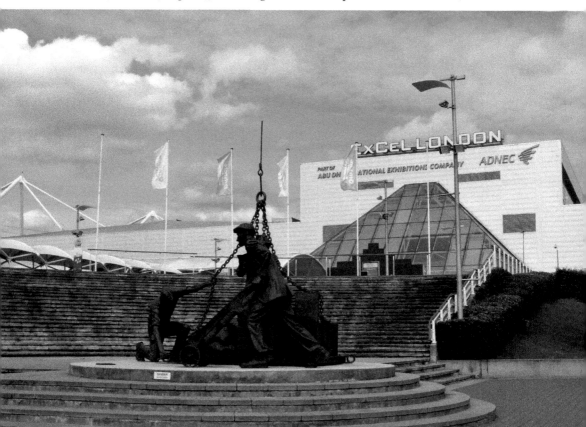

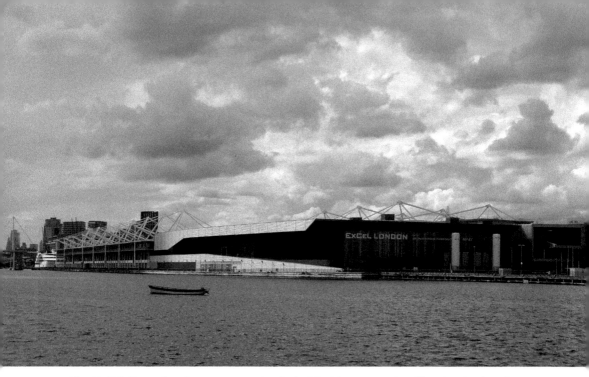

The ExCel Centre has frontage onto the dock. Maritime access is still maintained to the 'Royals' which has enabled it to stage events such as the London International Boat Show as vessels can gain access to moor alongside as here. Controversially, it has also hosted Arms Fairs when naval vessels have been on show to would-be foreign customers.

indoor sports. During April–May 2020 the Excel Centre served as the first Nightingale Hospital to treat Covid-19 patients. Later it was used as one of the first vaccination centres. It has also been used for sporting events such as boxing matches and triathlons with swimming taking place in the Dock.

46. Crystal Building, 1 Siemens Brothers Way, Royal Docks, E16

The Crystal was commissioned by Siemens and designed by WilkinsonEyre Architects and built by Arup Group originally as an exhibition centre and think tank. The style has been described as 'Neo-futurism'. The Royal Docks had been designated a Green Enterprise District, and this building has an 'outstanding' rating for environmental sustainability. The all-glass building challenged conventional ideas on sustainability, championing the use of advanced technology to minimise energy use. Six different types of highly insulated glass have been used in the cladding, each with varying levels of transparency to moderate solar gain and frame views into and out of the building. Reflective glass is used on the backward-leaning facets which face the sun, while transparent glass is used on the inner faces angled towards the ground. A sophisticated management system allows every element in this all-electric building to be monitored, benchmarked and fine-tuned for comfort and minimal energy use. Surplus energy can be returned to the National Grid.

Construction started in March 2011 and the building opened in September 2012. WilkinsonEyre were also the designers of the adjacent Emirates Air Link terminal, as well as Stratford station and the Jubilee line Stratford Market depot.

When first built the Crystal housed a permanent exhibition on sustainable development, but this proved to be less than permanent and in 2016 Siemens sold the building to the Greater London Authority as a base for the Mayor of London's £3.5 billion plan to regenerate the Royal Docks. Siemens moved out in 2019 and much of the building was then empty.

In the summer of 2020 there were suggestions on the BBC News that the London Mayor, Sadiq Khan, was considering moving the London Assembly from their headquarters at City Hall near Tower Bridge to the Crystal as a way of saving money. City Hall, designed by Sir Norman Foster, opened in 2002 and the GLA was paying more than £11 million a year to the Kuwaiti-owned St Martin's Property Group to rent it. Then on 3 November, shortly after a new government bail-out for Transport for London's losses during the coronavirus pandemic, it was formally announced that the Mayor was indeed proposing a controversial move to the Crystal building in 2021, and this move was confirmed during December. The London Assembly moved in during January 2022 after £14 million conversion work. The Mayor claimed that the move would save £61 million over five years, but this has been disputed by the London Assembly, the cross-party scrutiny body who found the figure was closer to £37 million.

The Crystal Building at the Royal Victoria Dock.

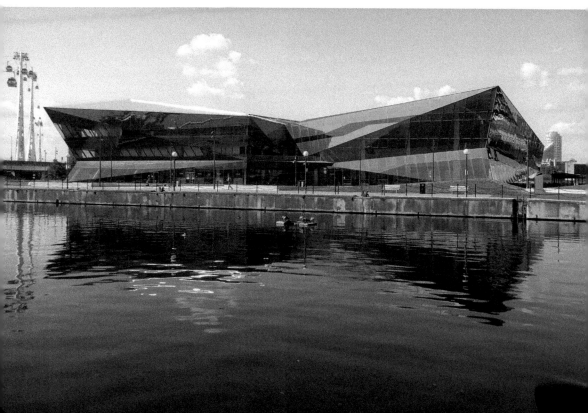

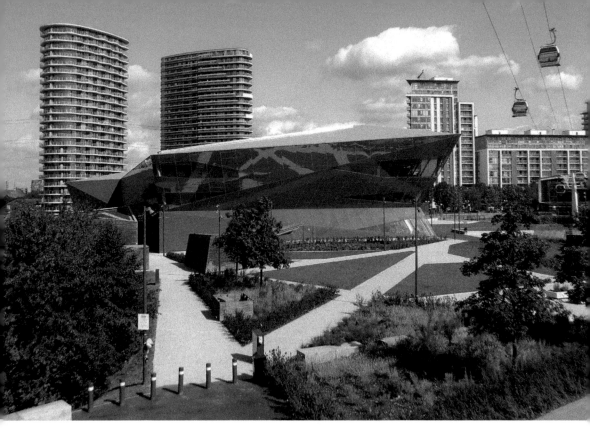

The Crystal Building looking north. To the right is the Emirates Air Line cable car, opened on 28 June 2012. This runs across the Thames between Greenwich Peninsula (near the O2) and Emirates Royal Docks (near the ExCel Centre – out of sight to the right). The Emirates Air Line was seen by many as a vanity project by the London Mayor, Boris Johnson, rather than a vital part of the transport infrastructure.

47. London (Olympic) Stadium, Queen Elizabeth Olympic Park, E20

When London was bidding to host the 2012 Olympic and Paralympic Games the government was considering an athletics-only stadium that would be largely disassembled afterwards with the lower tier remaining as a replacement for the Crystal Palace National Sports Centre. Construction started in May 2008 with Populous as the architects and Sir Robert McAlpine as main contractors. The stadium as built had a total capacity of 80,000, with a base tier of 25,000 seats. A lightweight demountable upper tier of steel and pre-cast concrete provided the other 55,000 seats. The stadium was completed in 2011, reportedly on time and at £537 million under budget.

 Although there were various measures to economise, including using just under a quarter of the amount of steel used in the Beijing stadium for the 2008 Olympics, and while it was promoted as an example of sustainable development, there was some criticism in the media – the *Times*'s architectural critic called the design 'tragically underwhelming'.

During the Games it was used for track and field events as well as the opening and closing ceremonies. After the Games it was rebuilt to become the London Stadium, now home to West Ham United who were (somewhat controversially) given a ninety-nine-year tenancy. It now has a capacity of 66,000, limited to 60,000 for football matches. The cost of the rebuilding at some £200 million was met by West Ham (£15 million), Newham Council (£40 million) with the London Legacy Development Corporation and the Government meeting the rest. A new roof, floodlights and replacement of the lower-tier seats all added to the cost. The removable seating design has also seen the stadium used for the 2017 IAAF World Championships, Rugby World Cup matches, and in June 2019 the first US Major League baseball game held in Europe.

The London Stadium now stands in the Queen Elizabeth Olympic Park, which was created by the London Legacy Development Corporation from part of the Olympic Park site. It is the largest new London park in over one hundred years and spans parts of Newham, Tower Hamlets, Hackney and Waltham Forest. Within its boundaries are also the London Aquatics Centre, Copper Box Arena, and Lee Valley VeloPark. The first stage opened in July 2013 when the site was

The London Stadium approach from Westfield as seen in 2020.

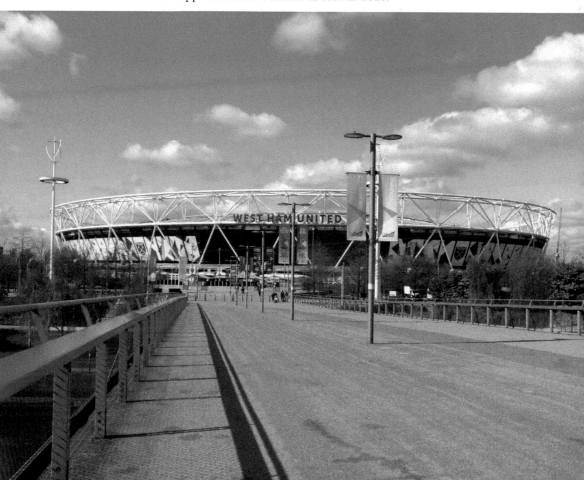

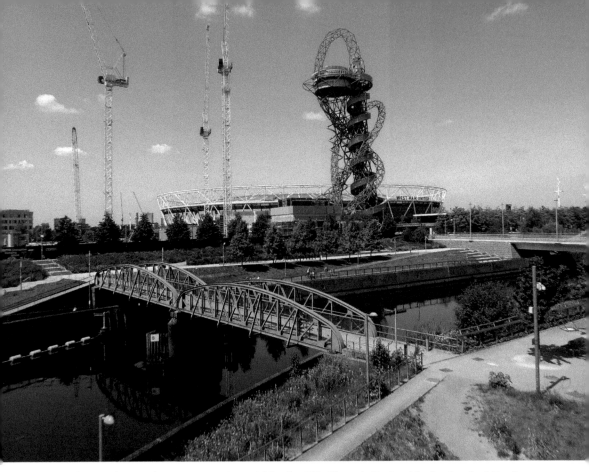

The London Stadium in its setting within the QE Olympic Park with the ArcelorMittal Orbit (*see* p. 89).

renamed to commemorate the Diamond Jubilee of Queen Elizabeth II. Most of the remainder reopened in April 2014.

48. London Aquatics Centre, Queen Elizabeth Olympic Park, E20

The London Aquatics Centre, designed by Zaha Hadid, was one of the showpieces of the Olympic site, completed in July 2011. It was actually designed before London won the Olympics bid and was adapted with terraced wing seating for 17,500 spectators located on the two sides. After the Games, these were removed and sold and the present glass walls installed, with the centre reopening to the public in March 2014. The centre is 160 metres long, 80 metres wide and 45 metres high. There is a 50-metre competition pool, a 25-metre competition diving pool and 50-metre warm-up pool. The steel roof weighs 3,200 tonnes. The structural engineers were Ove Arup & Partners and general contractors were Balfour Beatty. Because of the changes to the design made for and after the Olympics the total cost of £269 million was more than three times the original estimate of £75 million.

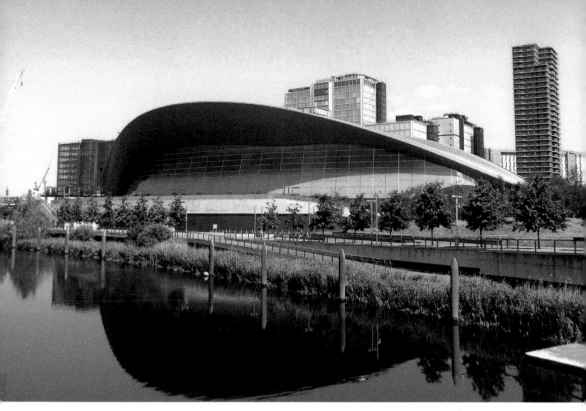

The London Aquatics Centre as seen in 2020. It is by the side of the Waterworks River, one of several rivers running through the Olympic Park site. Boat trips are available.

49. ArcelorMittal Orbit, Queen Elizabeth Olympic Park, E20

This 114.5-metre-high observation tower was designed by sculptor Sir Anish Kapoor and engineer Cecil Balmond as a lasting statement piece for the London Olympics, following an idea that came up in a conversation with London Mayor Boris Johnson. It is the UK's tallest sculpture and is made of steel supplied by steel company ArcelorMittal, 60 per cent of which was recycled. The ArcelorMittal Orbit is made from 600 pre-fabricated star-like nodes. These were precision-built by a team of 100 staff in Bolton, Lancashire and assembled on-site by four men and a crane. This created the superstructure of the sculpture before the lifts and interior viewing platforms were added. Some 35,000 bolts were used in the construction. Since 2016 the world's tallest and longest tunnel slide (178 metres) has been added to attract more visitors to the site.

'I wanted the sensation of instability, something that was continually in movement. Traditionally a tower is pyramidal in structure, but we have done quite the opposite, we have a flowing, coiling form that changes as you walk around it. ... It is an object that cannot be perceived as having a singular image, from any one perspective. You need to journey round the object, and through it. Like a Tower of Babel, it requires real participation from the public.' (Anish Kapoor)

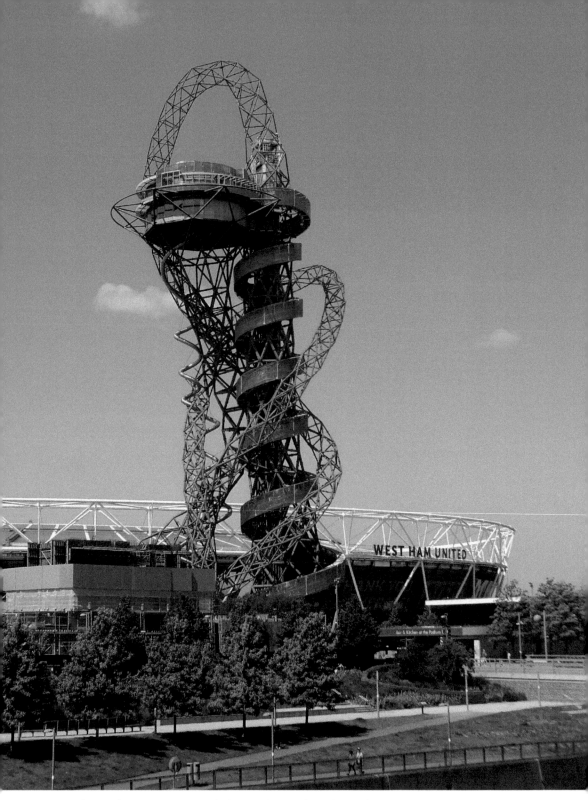

The ArcelorMittal Orbit with the London Stadium beyond.

50. Abba Arena, Pudding Mill Lane, E15

It may seem odd to include a building that had not yet been completed when I started compiling this list, but it also seems apt, because progress is not static. Many new buildings are being built at the time of writing, particularly at the major developments of Olympic Park Eastside and Sugar House Island, both in Stratford. However, I have included this because it is a one-off rather than a standard design, specially built for the production of Abba Voyage. This production, which took five years and one billion computing hours to create, features three-dimensional digital 'Abba-tars' of the supergroup in their younger days displayed performing on a 65-million-pixel flat screen with accompanying lighting, surround sound and special effects. The arena was specially designed for the project by British architectural company Stufish. The 3,000-seat hexagonal design gives equal-quality viewing from all points. The construction of the arena was unusual. The 745-tonne roof was built at ground level within the steel frame and then hoisted or jacked up to fit in place. It was opened on 26 May 2022. It is the world's largest demountable temporary venue with performances at present due to end on 28 May 2023.

A poster showing the design of the building.

Left: The roof
constructed at
ground level inside
the framework, 16
September 2021.

Below: The roof
has been raised up
within the framework,
29 September 2021.

Right: Construction proceeding on the entrance buildings, 14 April 2022.

Below: The completed building, 7 June 2022.

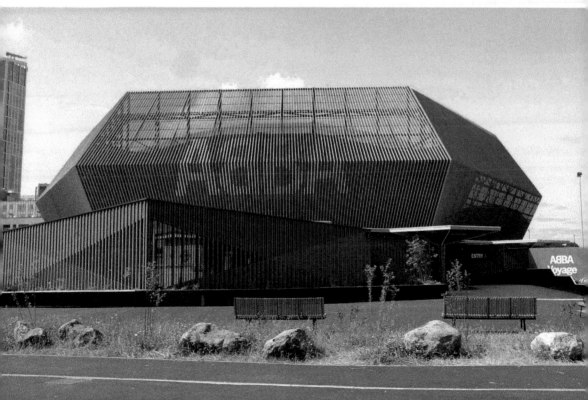

Postscript

Like any town or city, Newham is constantly evolving. Development is ongoing within the former Olympic Park site, with new phases of construction bringing homes, jobs and cultural facilities to the area. The former Press and Media centre has become 'Here East', a business innovation centre. The International Quarter is also being developed as a business hub. This will be a home for organisations as diverse as the Financial Conduct Authority and the Nursing & Midwifery Council. A new university campus, UCL East, is being built to the south of the ArcelorMittal Orbit. This will cater for 4,000 students studying subjects as diverse as robotics and conservation.

A new creative centre will open at East Bank in 2022–23. A joint venture with University College London, London College of Fashion, the BBC, Sadlers Wells and the V&A, this 'will bring their expertise, resources and profile to deliver a new creative centre for artistic excellence, learning, research, innovation, performance and exhibitions and they are already working with local organisations and partners ahead of the building's opening in 2022/2023'. Another major area being currently developed is the Sugar House Island, the area bordering the Bow Back Rivers west of Stratford and just before the boundary at Bow.

There has also been a lot of recent housing development, mostly in high-rise apartments around Canning Town and West Silvertown on former brownfield ex-industrial sites.

Will any of these modern redevelopments produce buildings that are worthy to be included in a future listing of Newham's 'Top Fifty Buildings'? Only time will tell.

Continuing development at the East Bank area of the Olympic Park site in 2021.

Acknowledgements, Bibliography and Further Reading

Thanks to Jess Conway, Archivist at Stratford Library.

The Newham Story: A short history of Newham (London: London Borough of Newham, 2016)

Batten, Malcolm, *East London Railways: From Docklands to Crossrail* (Stroud: Amberley, 2020)

Batten, Malcolm, *London's Transport and the Olympics: Preparation, Delivery and Legacy* (Stroud, Amberley, 2022)

Bloch, Howard, *Newham Dockland* (Stroud: Tempus, 1995)

Chambers, Veronika, Fred Chambers and Rob Higgins, *Hospitals of London* (Stroud: Amberley, 2014)

Connor, J. E., *Branch Lines around North Woolwich* (Midhurst: Middleton Press, 2001)

Edwards, A. C, *A History of Essex* (4th ed.) (Chichester: Phillimore, 1978)

Foley, Michael, *London's East End History Tour* (Stroud: Amberley, 2017)

Gorman, Mark & Peter Williams, *Forest Gate: A Short Illustrated History* (London: The authors, 2022)

Lund, Kenneth (comp), *Buildings in Newham* (London: London Borough of Newham, 1973)

Pewsey, Stephen, *Britain in Old Photographs: Stratford, West Ham & the Royal Docks* (Stroud: Sutton, 1996)

Ramsey, Winston G., *The East End Then and Now* (London: After the Battle, 1997)

Sanders, Dorcas & Nick Harris, *Forest Gate* (Stroud: History Press, 2012)

Williamson, Elizabeth and Nikolaus Pevsner, *London Docklands (Pevsner Architectural Guides: Buildings of England)* (London: Penguin, 1998)

Websites

Exploring East London: An excellent website with maps, created by the late Lawrence Rigal who died in 2010. Although no longer being updated, the website remains available and is an ideal source for anyone wanting to explore the area,

although some of the featured locations such as the North Woolwich Old Station
Museum have since closed or have been lost to redevelopment.

www.exploringeastlondon.co.uk
www.eastlondonhistory.co.uk
www.e7-nowandthen.org
www.hidden-london.com
www.newhamphotos.com
www.thamesfestival.org

Also
Free monthly newspaper *Newham Voices* – www.newhamvoices.co.uk